IMAGES
of America

LOUISVILLE'S
CRESCENT HILL

IMAGES
of America

LOUISVILLE'S
CRESCENT HILL

John E. Findling

ARCADIA
PUBLISHING

Published by Arcadia Publishing
Charleston, South Carolina

Printed in the United States of America

Library of Congress Control Number: 2011941628

For all general information, please contact Arcadia Publishing:
Telephone 843-853-2070
Fax 843-853-0044
E-mail sales@arcadiapublishing.com
For customer service and orders:
Toll-Free 1-888-313-2665

Visit us on the Internet at www.arcadiapublishing.com

This book is dedicated to the memory of my parents, Ruth and Willard Findling, who would have enjoyed living in Crescent Hill.

CONTENTS

ACKNOWLEDGMENTS

This book would not have been possible without the wonderful help and support I have been given by many people, some of whom grew up in Crescent Hill, some of whom work or worship there, and all of whom were eager to share their historical knowledge or pictures with me.

I want to thank Amy Perryman, my first editor at Arcadia, who invited me to do this project. Although Amy left for greener Arcadia pastures before the book was done, her replacement, Sandy Shalton, was just as helpful in carrying the project through to its conclusion. Through the Louisville Historical League, I met Barbara McGee, who provided me with my first batch of photographs for this book and who has been continually supportive of the project. Barbara Sinai helped me understand the history of Crescent Hill, especially the Eastover Park development, and graciously allowed me to use pictures from *Beautiful Crescent Hill*, a 1908 publication that she republished in 1978.

I am grateful to Mary Bateman, Judd Devlin, Doris Lamb, Steve Wiser, and Ed Perry—all local residents who let me copy their photographs, many of which have added a wonderful human touch to the book. Also, my thanks go to Sue Ritman of Reservoir Park; Joyce Cossavella, manager of the Peterson-Dumesnil House; Patti Marcum of the Crescent Hill Presbyterian Church; John Arnett of the Crescent Hill Baptist Church; Phyllis O'Daniel of the Masonic Homes of Kentucky; Bobbie Raibert of Holy Spirit Catholic Church; Sandra Lord of St. Mark's Episcopal Church; Marilyn Thomas of the Crescent Hill United Methodist Church; Keith Clements, who lent me pictures of the waterworks; Lynn Renau, who told me about Zachariah Sherley; Linda Gray, archivist of Boy Scout Troop 1; Diane Bonifield and Fithian Shaw Jr. from the Crescent Hill Golf Course; Kelley Dearing-Smith of the Louisville Water Company; Mary Margaret Bell, archivist for the Jefferson County Public School system; Trina Buschman from Chenoweth Elementary School; Rob Dividen and Susan Walko from St. Joseph Children's Home; Marty Perry from the Kentucky Heritage Council; Jason Fowler and Steve Jones, archivists at the Southern Baptist Theological Seminary; and Sister Martha Jacobs, archivist at the Ursuline Convent, for sharing their pictures and, in some cases, their stories with me. Syd Wright led me on a walking tour that was instrumental in my understanding of the nature of the neighborhood. Rob Gieszl of the Crescent Hill branch of the Louisville Free Public Library system facilitated meetings with local residents. Finally, special thanks to my partners at Collectors' Stamps, Ltd., and most of all, to my wife, Carol, for their forbearance and good wishes.

In the photograph credit lines, I have used the following abbreviations where appropriate: Crescent Hill Baptist Church (CHBC); Crescent Hill United Methodist Church (CHUMC); Crescent Hill Presbyterian Church (CHPC); Jefferson County Public Schools Archives (JCPS); Kentucky Heritage Council (KHC); Masonic Homes of Kentucky (MHK); St. Joseph Children's Home (SJCH); St. Mark's Episcopal Church (SMEC); Southern Baptist Theological Seminary (SBTS); and Ursuline Convent and Sacred Heart Academy (USHA).

INTRODUCTION

Crescent Hill is a largely residential neighborhood situated about four miles east of downtown Louisville. The specific boundaries of Crescent Hill are harder to pin down; over the years, different accounts of the neighborhood have attributed different boundaries to it. For the purposes of this book, however, Crescent Hill's northern boundary is Brownsboro Road. Its western boundary is Ewing Avenue, which runs from Brownsboro Road to a point two blocks south of Frankfort Avenue, and then across Beargrass Creek to the intersection of Grinstead Drive and Lexington Road. Its southern boundary is Lexington Road, and its eastern boundary is Cannons Lane between Lexington Road and Frankfort Avenue, then east on Frankfort Avenue to the eastern edge of the Masonic Homes property, and from there north to Brownsboro Road at a point just east of Country Lane and Chenoweth School.

Early in the 19th century, the Louisville and Shelbyville Pike, now Frankfort Avenue, was a frequently traveled road for stagecoaches. It was renamed the Louisville and Lexington Turnpike in 1817, and families began to build country estates in the area, known generally as Beargrass because of the nearby creek, during the 1820s. The Louisville and Frankfort Railroad was built alongside the turnpike in the late 1840s, and the Southwestern Agricultural and Mechanical Association bought a 38-acre tract of land in the early 1850s, next to the rail line about where St. Joseph Children's Home and Crescent Avenue are today. Annual agricultural fairs were held there until 1863, when the land was sold to the Louisville and Jefferson County Association. That group did little with the property before declaring bankruptcy in 1874, after which the land was subdivided into a neighborhood called Fair View.

Around this time, the name Crescent Hill was first applied to the area. The origins of the name are unclear, but local historian Samuel W. Thomas has identified three possible sources for the name. The first and least likely is that Crescent Hill was named for New Orleans, the "Crescent City." The second asserts that Catherine Anderson Kennedy, a resident, noted a crescent-shaped reservoir or lake from a hill in the parkland in the water company property off of Frankfort Avenue. This is plausible since the Kennedy family was prominent in the area, but Thomas believes that the name was in use before she saw the crescent-shaped body of water. Thus the third theory seems the most likely. According to Thomas and others, the name Crescent Hill refers to the uphill curve of Frankfort Avenue from Clifton Avenue, in the Clifton neighborhood, to the site of the old fairgrounds. This crescent-shaped curve might have been more obvious before Frankfort Avenue was commercially developed.

At any rate, the name Crescent Hill may have seen its first official use in 1879, in connection with the water company's new Crescent Hill reservoir. Two years later, the name of the post office at the corner of Frankfort Avenue and Crescent Court was changed from Fair Grounds to Crescent Hill and remained such until 1903. In 1884, Crescent Hill was incorporated as a sixth-class city in Kentucky, but beginning in 1894, the City of Louisville annexed parts of Crescent Hill, finishing that task in 1922.

By the turn of the 20th century, the country estates that had been built in much of Crescent Hill were giving way to subdivisions and streets that were lined with more modest houses. Relatively easy travel to downtown Louisville was possible with commuter trains and streetcars, which were mule-drawn until 1901, and Crescent Hill began to take on the attributes of a pleasant suburb. Frankfort Avenue was paved in 1902, and the first public school was opened in 1905. By 1910, the Presbyterians, Methodists, Episcopalians, and Baptists all had churches in Crescent Hill. By 1916, a number of businesses had opened on Frankfort Avenue between Ewing and Stilz Avenues, where the water company property began.

The early residents of Crescent Hill understood the value of their neighborhood. In 1908, the Crescent Hill Improvement Association published a book titled *Beautiful Crescent Hill*, which was filled with pictures of homes that had recently been built in the neighborhood, as well as advertisements from real estate companies that could help any interested reader acquire one of these homes. Seven years later, a group called the Crescent Hill Forward Club sponsored what it called "Crescent Hill Big Day" and published an elaborate souvenir program full of pictures and advertisements extolling the virtues of the neighborhood. In his *Crescent Hill Revisited* (1987), Samuel W. Thomas recorded the memories of many who lived in Crescent Hill at this time, and they spoke of the safe, pleasant, and uncomplicated childhoods they enjoyed. In 1908, real estate developer Clarence Gardiner, said, "Crescent Hill will continue to grow in popularity and value . . . its suburban character is too firmly fixed to ever be changed [and] the family seeking the joys of the country with the conveniences of the city has nowhere else to go."

By the 1920s, much of Crescent Hill had been subdivided into residential lots, but the neighborhood was changed dramatically by the arrival of the Southern Baptist Theological Seminary, which moved from downtown to a large new campus on Lexington Road, and the Masonic Widows and Orphans Home, which moved from Old Louisville to an expansive tract on Frankfort Avenue. Along with the St. Joseph Children's Home and the Ursuline-Sacred Heart Academy complex, these new institutions made Crescent Hill a center of charitable and religious institutions.

Although Louisville's continuing growth eastward in the mid-20th century made Crescent Hill less of a geographically distinctive suburb, it was able to maintain its character and be an enjoyable place in which to grow up. Syd Wright, who lived in Crescent Hill and attended school there in the 1950s, remembers Crescent Hill as a "great place to grow up." He played punchball, a baseball-like game played with a volleyball, behind the Methodist church. He also participated in city league sports teams sponsored by the Crescent Hill Baptist Church, where one had to go to church only twice a month to be eligible. He hung out at the DJ Eat Shop where the first double cheeseburger was created, and Lacy Jenkins' Snack Shop, which featured a jukebox and a pinball machine. He spent time at Norville's Service Station, where mechanic Charlie Burke was inordinately proud of his 1937 Hudson Roadster, and at Ward's Barber Shop, which is still there. Everyone knew everyone else because they all went to the same schools and to one of the local churches.

In 1966, the Crescent Hill Community Council was organized as a neighborhood improvement association to deal with matters that have an impact on the quality of life in the neighborhood. This organization acquired the Peterson-Dumesnil House from the Jefferson County Board of Education in 1984, oversaw its renovation, and maintains it today as a community center and special events venue. The community council also worked to coordinate relief efforts after a tornado ripped through parts of Crescent Hill on April 3, 1974. It damaged 480 houses, of which 80 or so had to be demolished.

As of 2011, Crescent Hill retains is distinctive neighborhood character with its active community council, a quarterly newsletter, and well-planned community events during the year. With a population of around 8,000, depending on how one defines the boundaries of the neighborhood, and many locally owned businesses along Frankfort Avenue, it remains a place where "everybody knows everybody else."

One

PIONEERS AND
EARLY HISTORY

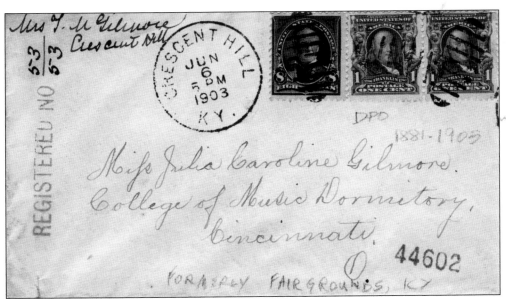

CRESCENT HILL POSTMARK, 1903. Crescent Hill had its own post office located near the corner of Frankfort Avenue and Crescent Court from 1881 to 1903. During most of this period, Crescent Hill was an independent sixth-class city in Kentucky. By 1903, Louisville had annexed most of Crescent Hill, and the post office was merged into the Louisville system. (Courtesy of the author.)

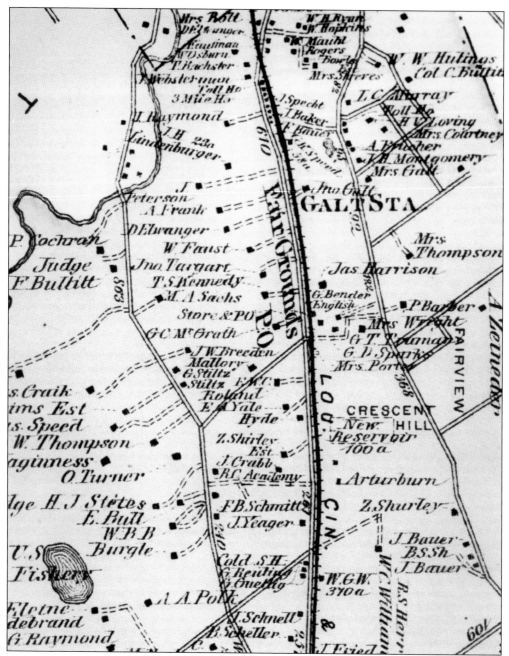

MAP FROM 1879 ATLAS. This map of what would become the Crescent Hill area was published in the *Atlas of Jefferson and Oldham Counties Kentucky* in 1879. The map is oriented so that west is to the top. The dark line through the center of the map is the railroad track with Frankfort Avenue next to it. Note the Fair Grounds Post Office name in the center of the map; this post office was renamed Crescent Hill in 1881. Only a few side streets have been laid out, and the many names on the map identify those Louisville families who had country estates in the area.

OSCAR TURNER, 1825–1896.
This engraving, originally
published in the 1896 *Memorial
History of Louisville*, shows Oscar
Turner, a prominent Louisvillian,
who served in the US House
of Representatives from 1879
to 1885 and moved to Crescent
Hill after retiring from Congress.
He lived in the Morning-Side
addition along Frankfort Avenue
(Shelbyville Turnpike), opposite
Park Avenue, which later was
renamed South Bayly Avenue.

ABRAHAM G. MUNN, 1818–1910.
This engraving, originally
published in *Memorial History
of Louisville*, shows A.G. Munn,
a native of New Jersey. He came
to Louisville as a young man and
owned a highly successful business
manufacturing agricultural
implements. In either 1849 or
1850, he bought a 40.5-acre tract
in the eastern part of Crescent
Hill, near Frankfort Avenue and
Cannons Lane, in an area known
as Spring Station. Munn was
active for decades in the Unitarian
Church, where he established
a Sunday school in 1841 and as
late as 1896, was a member of
the church's board of trustees.

JOHN D. TAGGART. Active in both the banking business and in railroads, Taggart served on the first board of directors of Fidelity Trust Company in 1882, and was on the board of the Louisville and Nashville Railroad in the 1890s. In 1871, he traded 200 acres of farmland in Shelby County for Willowbrook, the Gray family estate that was located along the south side of Frankfort Avenue between Birchwood and Stilz Avenues. Nine years later, he sold the estate to Thomas H. Hays for $12,000. This engraving of Taggart was originally published in *Memorial History of Louisville* in 1896.

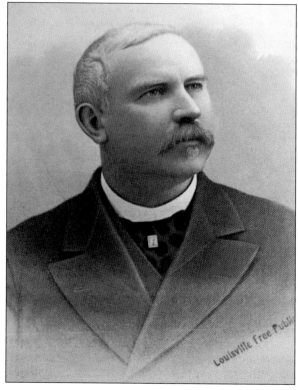

THOMAS H. HAYS, 1837–1909. Hays, shown in this engraving published in the 1896 *Memorial History of Louisville*, was a major in the Confederate Army who served in the Sixth Regiment of the Kentucky Brigade, fought at the Battle of Shiloh and then became attached to the Inspector General's office. In 1880, he bought Willowbrook from John D. Taggert and sold it two years later to George Birch for $5,000 and a lot on Broadway. He also built a family home on land that eventually became the site of Waverly Hills Sanitorium in 1883.

WILLIAM C. HITE, 1820–1883.
The man shown in this
engraving, which was published
in *Memorial of Louisville*, is for
whom Hite Avenue in Crescent
Hill is named. William C. Hite
was involved in a variety of
business ventures. He was a
leading promoter of Reilly's,
or People's, telegraph line in
the 1850s and later had an
import business with George
W. Small, was a manager
of Cave Hill Cemetery,
and owned a ferry boat.

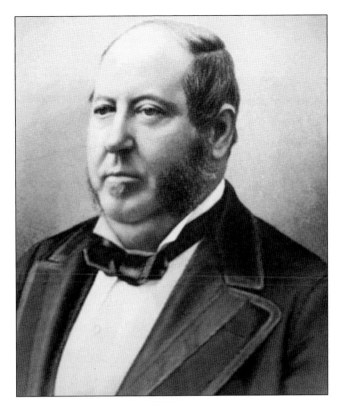

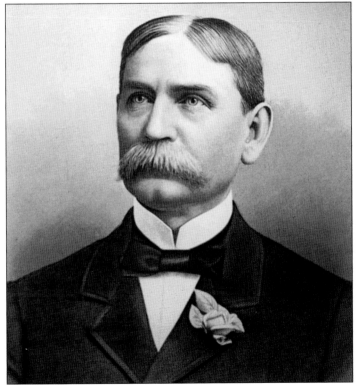

**JOSIAH T. GATHRIGHT,
1838–1919.** A colonel
in the Union Army
during the Civil War,
Josiah Gathright founded
a saddlery and harness
business that was later
known as Harbison and
Gathright. He married
Emma E. McGrath,
whose father owned
Crescent Court. His
country estate at 110
Crescent Court, built
by Edward Bell, was
the largest and most
elegant house on that
street. This engraving
of Gathright was first
published in *Memorial
History of Louisville.*

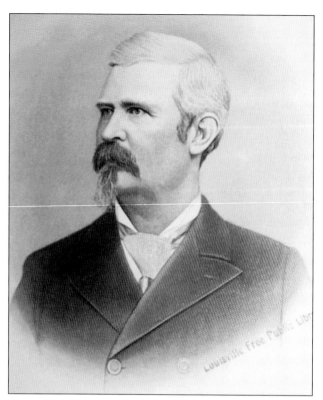

JOHN COLGAN, 1840–1916.
Colgan was a pharmacist and drugstore proprietor in the 1860s and was appointed a trustee of the Louisville College of Pharmacy in 1870. He is said to have been the first to make chewing gum, which he did by incorporating chicle into a cough medicine formula to make a product called Colgan's Taffy Tolu. This engraving of Colgan was originally published in *Memorial History of Louisville*.

THOMAS L. ALEXANDER, 1797–1880. This engraving, published in *Memorial History of Louisville*, is of South Carolina native Thomas Alexander. He bought an estate in 1864 from J.L. Crutcher in an area that was supposed to have become Eastern Park. However, the park was never built because the water company would not relinquish the needed land at that time, and Cherokee Park was built instead.

GEORGE W. FRANTZ.
The Frantz family was prominent in both Crescent Hill and Clifton. George's father, Daniel (1810–1881), owned a house along Frankfort Avenue, where Eastover subdivision now is. He established a successful tannery business that his son George took over in 1881. George owned a large house on Sycamore Avenue in Clifton, along with 18 acres of land that stretched from Brownsboro Hill to Brownsboro Road. This engraving of George Frantz was published in *Memorial of Louisville* in 1896.

JOHN D. WHITE, 1849–1920. This engraving, published in *Memorial History of Louisville*, is of lawyer and US House of Representatives member (from 1881 to 1885) John D. White. He also ran for governor of Kentucky on the Prohibition Party ticket in 1903. In the 1880s, he bought a lot in Fair View, near the site of the old fairgrounds, and built a large house at the corner of Crescent and Field Avenues. In 1919, he served on a committee to look into "improving the conditions" under which trains ran through Crescent Hill.

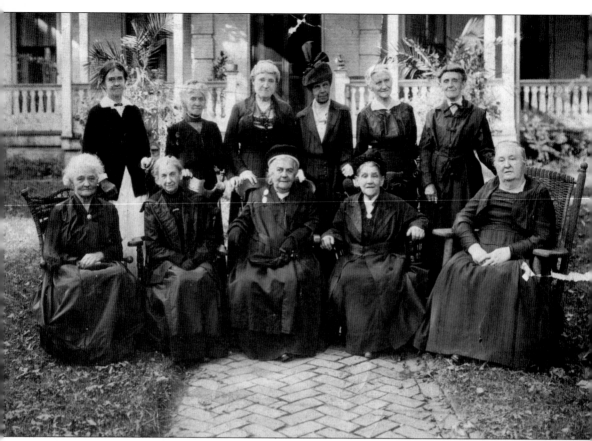

THE LADIES OF CRESCENT HILL. This photograph, taken in front of the Emmet Field house at the corner of Crescent and Field Avenues, includes the most prominent ladies of Crescent Hill around 1900. Those who can be identified are, from left to right, (first row), three unidentified women, Mrs. John T. Gaines, and unidentified; (second row) Mrs. Peyton Short Kinkead, Mrs. Emmet Field, unidentified, Mrs. Horton, Mrs. T.P. White, and unidentified. (Courtesy of Joyce Cossavella.)

Two

HOMES

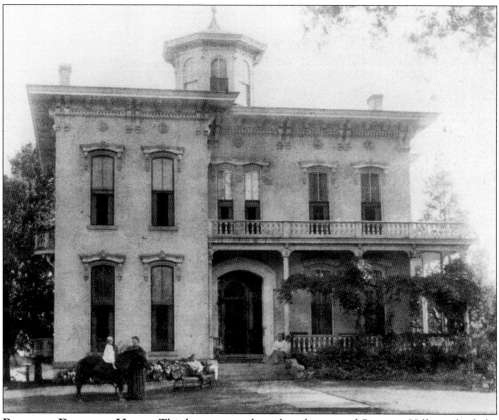

PETERSON-DUMESNIL HOUSE. This house, now the cultural center of Crescent Hill, was built for Joseph Peterson, a tobacco wholesaler, in 1869. Possibly designed by noted Louisville architect Henry Whitestone, the Italian Villa–style home sits on a 1.3-ace lot on the east side of what is now south Peterson Avenue. The house passed down to the Dumesnil family in the 1890s, was acquired by the Jefferson County Board of Education for use as a teachers' club and conference center in 1948, and purchased by the Crescent Hill Community Council in 1984 for $165,000. Sitting on the horse in this early-20th century photograph is Edward Rowland Dumesnil. (Courtesy of Joyce Cossavella.)

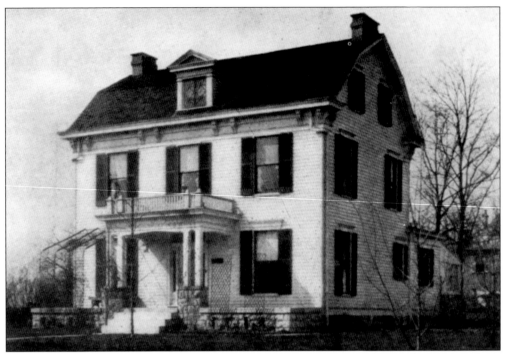

ORMSBY HOUSE. Located at 215 South Peterson Avenue, this was the home of H.D. Ormsby, a cashier and later vice president of the National Bank of Kentucky. When the house was built around the turn of the 20th century, the address was 250 South Peterson. After Louisville underwent an extensive street numbering change in 1908, the Ormsbys' address was 215 South Peterson. In the early 1920s, Ormsby moved to South Third Street in Old Louisville, and other families have lived in the house ever since. (Courtesy of KHC.)

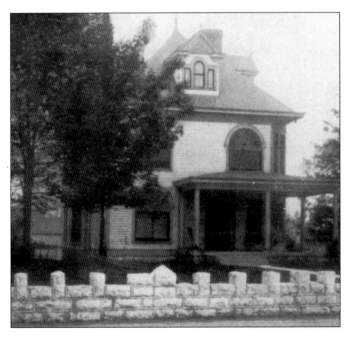

NEWTON C. SHOUSE HOUSE. This c. 1907 house, located at 2428 Frankfort Avenue, was built in an eclectic classical revival style, with a later addition extending the structure from the left bay of the facade. The second-floor windows with their arched stained glass transoms are particularly noteworthy. The first occupant of the house was N.C. Shouse of J.D. Shouse Tobacco Brokers. The Shouse family lived in the house until the mid-1930s, and the building is now the Arch C. Heady Funeral Home (see page 83). (Courtesy of KHC.)

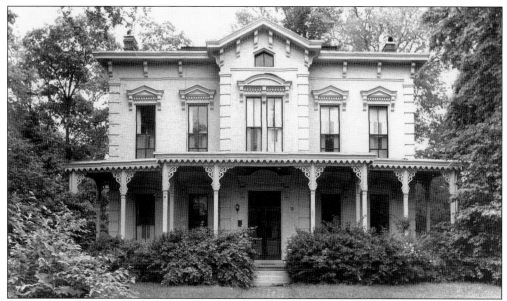

EMMET FIELD HOUSE. This c. 1878 house was built at 2909 Field Avenue, at the corner of Crescent Avenue, for Jonathan C. Wright, who was in the mill supply business. In 1890, his widow sold the house to Emmet Field, a prominent judge, although the Fields had lived in the house since 1886, the year that Field first became a judge. Field died in 1909, and the house was converted into apartments in 1916. Field's widow, Susan, lived in one until her death in 1938. The house underwent major renovations in 1998 and 1999. (Courtesy of KHC.)

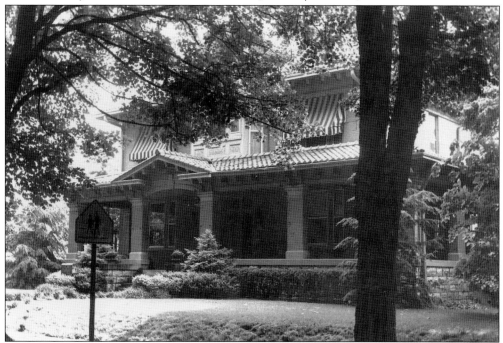

KURFEES HOUSE. Located at 235 South Galt Avenue, this relatively extravagant Craftsman bungalow was built for James R. Kurfees, president of the Kurfees Paint Company, in 1915. It remains essentially unchanged today. (Courtesy of KHC.)

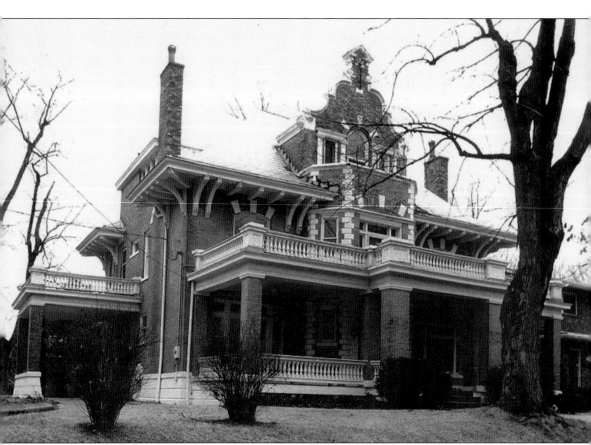

RUSSELL HOUSE. This elegant mansion located just behind the Crescent Hill United Methodist Church at 205 South Peterson was designed by Louisville architects Ossian P. Ward and J.B. Hutchings. (Courtesy of KHC.)

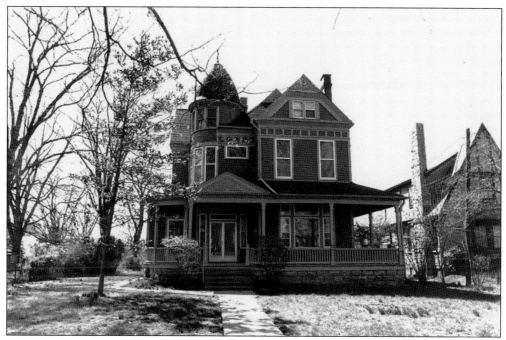

188 CRESCENT AVENUE. Built in 1900 in the popular Queen Anne style, this house is just across the street from the Emmet Field House. It is distinctive for its gables and jigsaw carpentry decorative work. The original owner was Henry Wilken, a supervisor with the Kentucky Distillers and Warehouse Company. (Courtesy of KHC.)

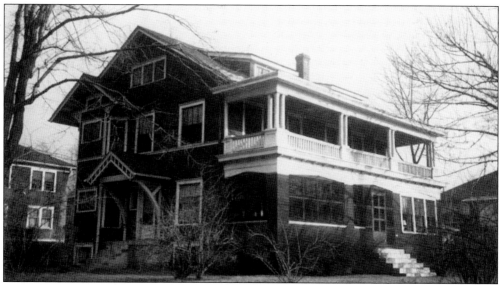

113 TO 119 FOREST COURT. Not a landmark house, but an interesting example of the bungalow style applied to a four-unit apartment building possibly dating to the early 1920s. Forest Court is an almost hidden one-block-long street just west of Hillcrest, and this house narrowly escaped serious damage during the 1974 tornado. (Courtesy of Barbara McGee.)

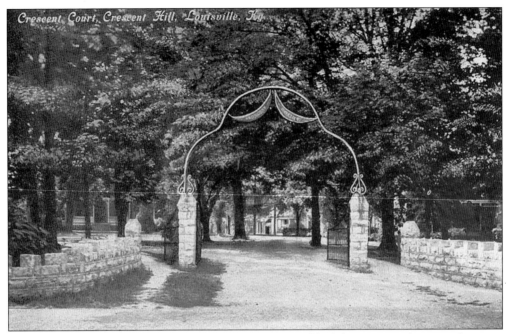

CRESCENT COURT ENTRANCE. Crescent Court is a two-block-long street that runs between Frankfort Avenue and Grinstead Drive. This c. 1910 postcard view shows an entrance arch at the north end of the street, placed there by residents to give their street a mark of distinction. It has since been removed. (Courtesy of the author.)

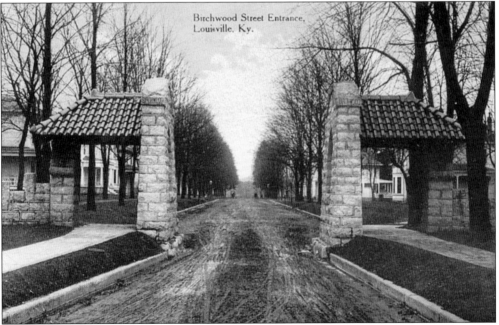

BIRCHWOOD AVENUE ENTRANCE. Birchwood Avenue runs both north to Brownsboro Road and south to Grinstead Drive from Frankfort Avenue. This entrance arch was at the intersection of Frankfort and South Birchwood. This entryway has been replaced by stone pillars and a low stone wall that look quite similar. (Courtesy of the author.)

YOU Can If YOU Will

Own Your Own Home

We will plan, build and finance a home to suit your own ideas. We can do more than anybody for you in price and terms

Crescent Hill Property is Our Specialty

See the houses we are building in

Hillcrest and on Aubert and Wentworth Aves.

Our Mr. G. Y. Hieatt lives in Hillcrest and Mr. Garrett lives in Crescent Avenue, and they can see you any evening.

HIEATT BROTHERS
HOME BUILDERS

4th Floor Inter-Southern Building

Home Phones 6663
Cumb. Phone M. 1282
6863

5th and Jefferson Streets.

HIEATT REALTY ADVERTISEMENT, 1915. This advertisement, which occupied the entire back cover of the souvenir program for Crescent Hill's "Big Day" in 1915, was run by a large Louisville real estate company that had offices in various locations in downtown Louisville for more than 50 years. For many years, they were in the Inter-Southern Life Insurance Building at Fifth and Jefferson Streets, but they also spent time on Broadway and on Fifth Street near Chestnut Street. (Courtesy of Barbara Sinai.)

WEST SIDE, SOUTH BIRCHWOOD STREET. This street, which runs north and south from Frankfort Avenue, was developed between 1908 and 1914, with many houses in a classical revival or American Foursquare style. In the 300 block of South Birchwood are several homes in the Craftsman style. This photograph shows an American Foursquare house at 210 South Birchwood (center) and is flanked by the houses at 214 (left) and 206. (Courtesy of KHC.)

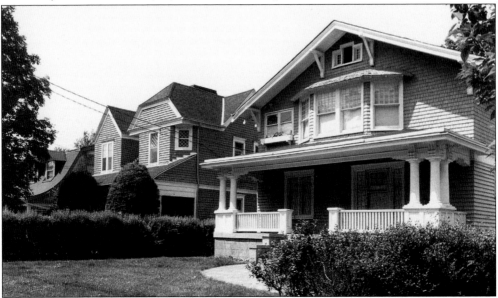

WEST SIDE, SOUTH PETERSON AVENUE. Peterson Avenue was originally the driveway off of Frankfort Avenue to the Peterson-Dumesnil house when it was built c. 1869. Later, it became a public street and many of the houses on it were built in Craftsman, Classical revival, and Colonial revival styles between 1906 and 1910. The southern part of the street is paved with glazed brick, the most prominent such street in the city. This photograph shows the houses at 326 (left), 330 (center), and 334 South Peterson. (Courtesy of KHC.)

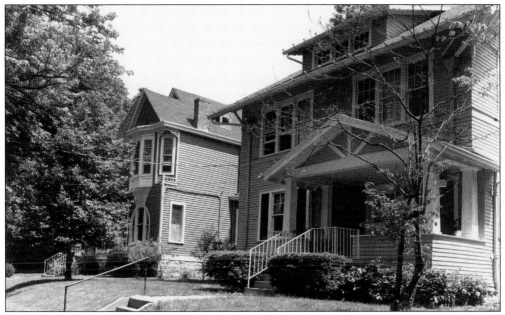

East Side, N. Hite Avenue. N. Hite Avenue, which runs between Frankfort Avenue and Brownsboro Road, is unusual in that much of it has a grassy median. Among the houses along the street are several in the Queen Anne style and one house, located at 122 N. Hite, is in the so-called Stick style, which is rare in Louisville. This photograph shows 149 N. Hite (left) and 143 N. Hite. (Courtesy of KHC.)

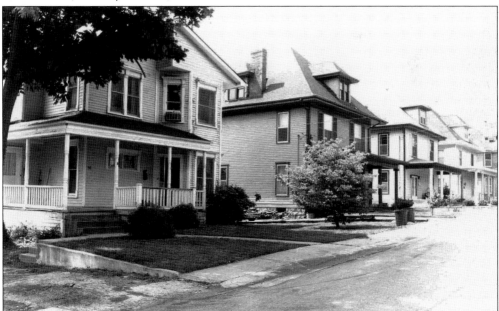

114 to 120 Crescent Avenue. Crescent Avenue, which runs between Frankfort Avenue and Brownsboro Road, began to be developed as early as the 1870s, after the nearby fairgrounds were sold. Most houses were built between 1900 and 1910 in various Classical Revival styles. Of the houses in this early 1980s photograph, only the nearest house located at 120 Crescent survives. An apartment complex has replaced the others. (Courtesy of KHC.)

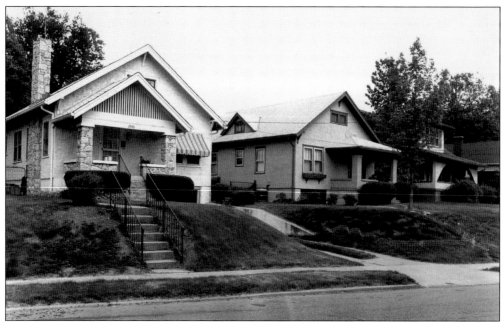

2903 TO 2907 SPRINGDALE AVENUE. Springdale is a short, curving street built into the side of a hill that runs off Grinstead Drive not far west of Stilz Avenue. Most of the houses here are bungalows that were most likely built in the late 1910s or early 1920s. (Courtesy of KHC.)

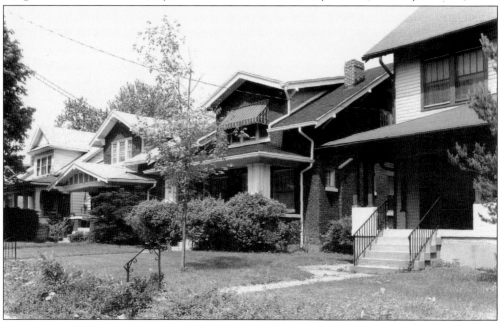

115 TO 119 HILLCREST AVENUE. Hillcrest Avenue, just east of Crescent Avenue, saw its major development between 1910 and 1920, when Craftsman and American Foursquare homes were built. Many of the homes here were built by the Cherokee Heights Land Company, which promoted them by citing the advantages of suburban living. Although many houses on Hillcrest were damaged or destroyed in the 1974 tornado, the houses in this photograph survived and remain private homes today. (Courtesy of KHC.)

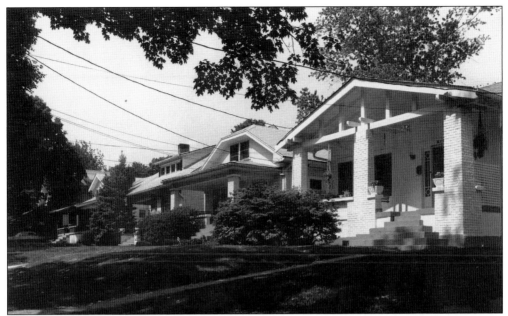

219 to 227 Pennsylvania Avenue. Local businessman Charles Philip developed Pennsylvania Avenue around the same time nearby Hillcrest Avenue was built up. In the 1910s and 1920s, the rise of savings and loan associations provided new outlets of credit that enabled many more people to become homeowners. The homes in this photograph are still private residences today. (Courtesy of KHC.)

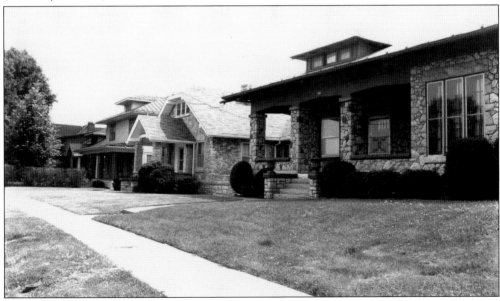

214 to 218 Stilz Avenue. Stilz Avenue constitutes the western boundary of the water company property, and most of its homes are on the west side of the street. These are a mix of American Foursquare, bungalow, and fieldstone houses. Stilz is named for Godfrey Stilz, a German immigrant who came to Louisville in 1835 and farmed 38 acres in what became Crescent Hill. The father of 12, he built a large home on Grinstead Drive (then Long Avenue) that was a local landmark for many years. (Courtesy of KHC.)

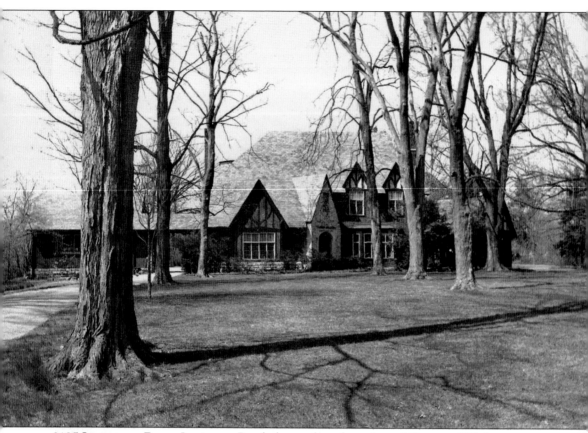

3185 LEXINGTON ROAD. Lexington Road, the southern boundary of Crescent Hill, boasts some of the most elegant houses of the entire neighborhood. This Tudor Revival–style house, which dates to 1926, is one of the finest examples of later development in Crescent Hill. The original owner was J. Elliot Riddell, the president of Riddell Furniture Company. (Courtesy of KHC.)

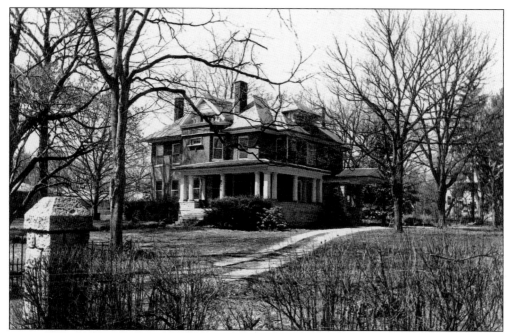

DANNENHOLD HOUSE. J.F. Dannenhold, president of the Main St. Tobacco Warehouse, was the first owner of this house, which was built c. 1910 in a Tudor Revival style. The house was brick with stone and glass decorative elements and was considered one of the most impressive homes along Lexington Avenue at the time of its construction. (Courtesy of KHC.)

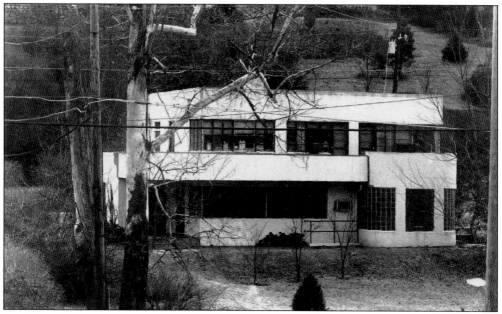

500 UPLAND ROAD. One of the few examples in Louisville of the International style is this stucco and glass house that was designed by architect Samuel Malloy and built in 1938. The International style was popularized in Europe in the late 1920s. The original owner was Maurice Miller, a sanitary engineer for the county health department. The house remains today, essentially unchanged on the exterior. (Courtesy of KHC.)

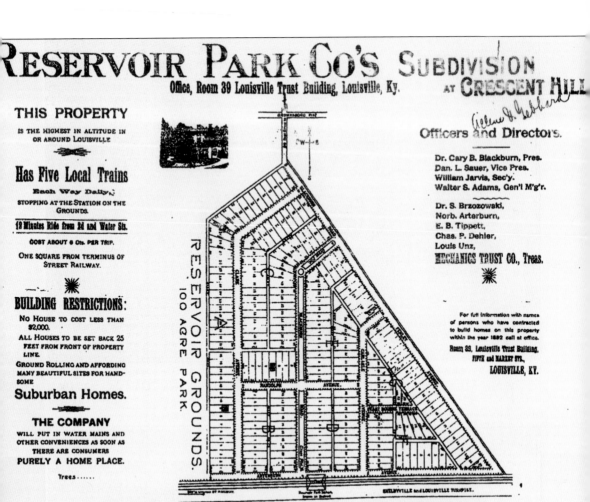

RESERVOIR PARK PLAN. This c. 1892 plan for the subdivision of Reservoir Park, which lies just to the east of the water company's 1879 reservoir, is typical of the subdivision layouts that developers produced during the late-19th and early-20th centuries in Crescent Hill. (Courtesy of Sue Ritman.)

3128 RANDOLPH AVENUE. Built in the 1840s as a country estate, this house became the centerpiece of the Reservoir Park subdivision. With the land around it sold off and subdivided, the house is just a nice residence on a pleasant street today. (Courtesy of the author.)

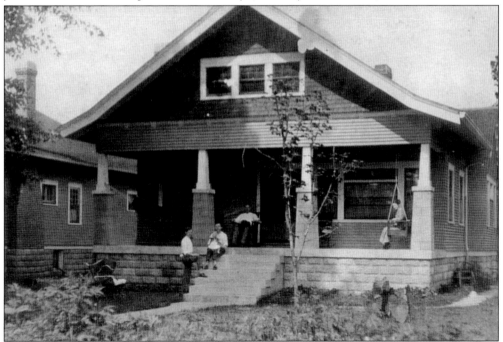

130 N. CRESTMOOR AVENUE. This single-family residence built in 1910, is typical of the Reservoir Park subdivision. Many houses from this era remain substantially unchanged in this pleasant and secluded subdivision. (Courtesy of Sue Ritman.)

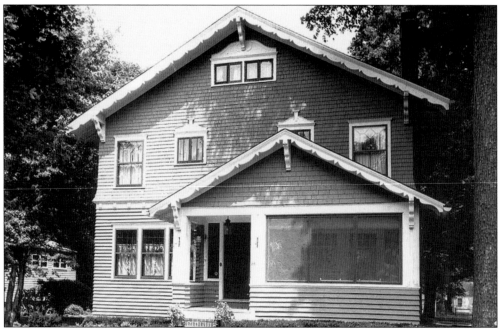

23 EASTOVER AVENUE. The subdivision of Eastover Park is located south of Frankfort Avenue and east of the waterworks property. It is built around one main street, Eastover Avenue, and a cross street at the end of Eastover. Eastover Park was and still is distinctive because its main street was quite wide. The homes built along it, which were constructed mostly in the first decade of the 20th century, were well spaced. (Courtesy of KHC.)

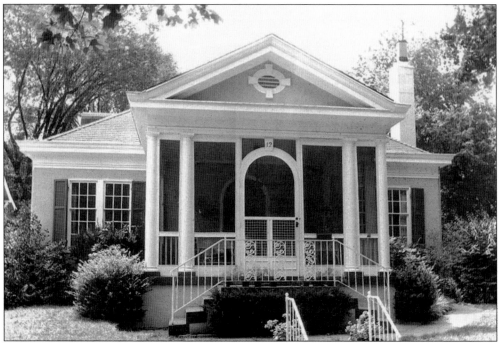

12 EASTOVER AVENUE. This distinctive Eastover Park house blends Colonial and Greek Revivals into an attractive 1910 residence. (Courtesy of KHC.)

Three

SCHOOLS

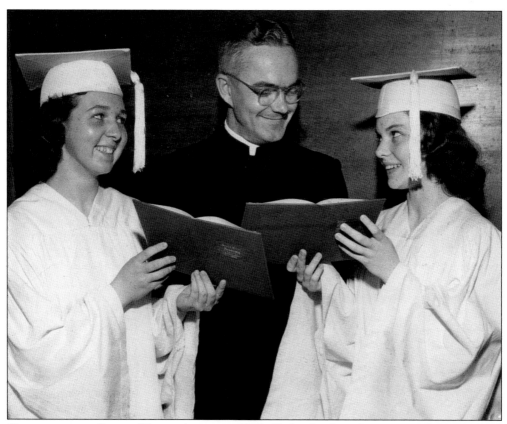

GRADUATION AT SACRED HEART ACADEMY, 1950. High school graduations are always a special occasion for students and their families. The two beaming Sacred Heart graduates from 1950 shown here are Madeleine Ann Boyle (left) and Shirlie Helen Kraemer. Sharing their happiness is Msgr. William McKune. (Courtesy of USHA.)

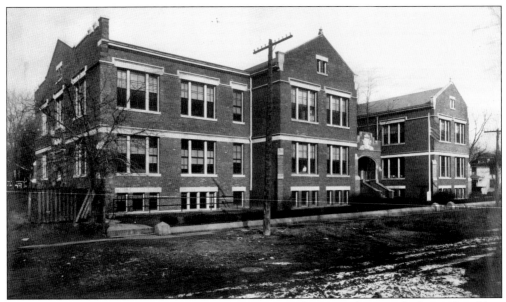

GEORGE ROGERS CLARK ELEMENTARY SCHOOL, 1967. This 1967 photograph shows the oldest public school in Crescent Hill, Clark School, which was built in 1905 and was originally called the Crescent Hill-Clifton School. In 1909, it was renamed the Edward Gottschalk School, in honor of a school board member. In 1911, it became George Rogers Clark School. Louisville architects J.B. Hutchings and Harry Franklin Hawes designed the school. In 1922, an addition was built onto the school. (Courtesy of JCPS.)

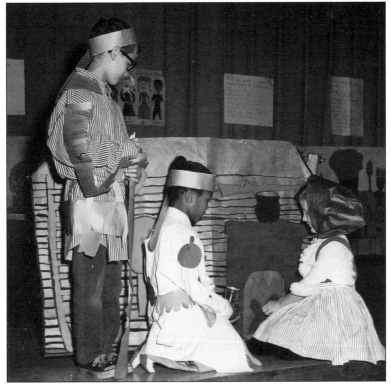

PAGEANT AT CLARK SCHOOL, 1953. In 1975, the school closed because of declining enrollments, and a group of investors bought the building and converted it into 35 apartments and condominiums called Clark Place in 1981. This photograph depicts a pageant about the early history of Louisville that was performed at the school in 1953. (Courtesy of JCPS.)

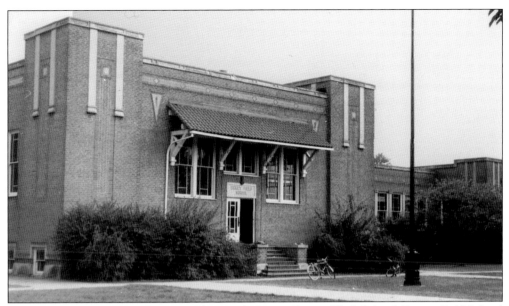

EMMET FIELD ELEMENTARY SCHOOL. Along with George Rogers Clark School, Emmet Field School was one of the two public schools that served Crescent Hill during the early 20th century. Named for a prominent judge, Field School was designed by architect J. Earl Henry and opened with five teachers and 155 students in September 1915. It was the first one-story school in the city. This photograph shows the facade of the school before an extensive makeover in 1970. (Courtesy of CHUMC.)

CEREMONY AT FIELD SCHOOL, 1971. Gloria Smiley, principal of Field School and the school system's first African American principal, is shown in this photograph receiving an award for innovative programs from Kentucky governor Louie B. Nunn. Newman Walker, the superintendent of Jefferson County Schools, is seen to the left. (Courtesy of JCPS.)

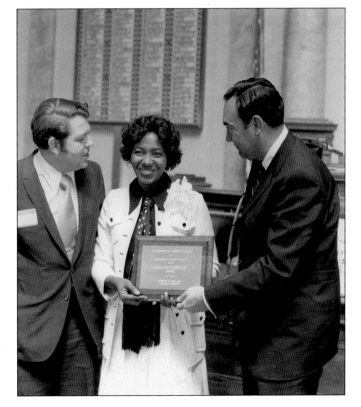

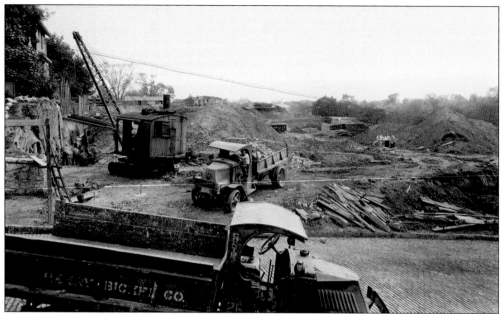

BARRET JUNIOR HIGH SCHOOL UNDER CONSTRUCTION, 1930. In 1930, with the growth of the student population in both Clark and Field elementary schools, authorities determined that a junior high school was needed in Crescent Hill to handle the students from the local elementary schools. This photograph, taken on September 23, 1930, shows some of the site preparation in progress. (Courtesy of JCPS.)

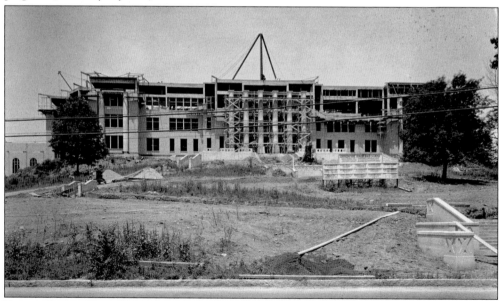

BARRET JUNIOR HIGH SCHOOL UNDER CONSTRUCTION, 1931. The construction of Barret Junior High School was extremely well documented by photographers, and there are hundreds of photographs in the Jefferson County Public School archives. This photograph, taken on July 13, 1931, shows the front elevation of the school, perhaps midway through the construction process. The style chosen for the school was a modified Classical style, popular in those days for public buildings. (Courtesy of JCPS.)

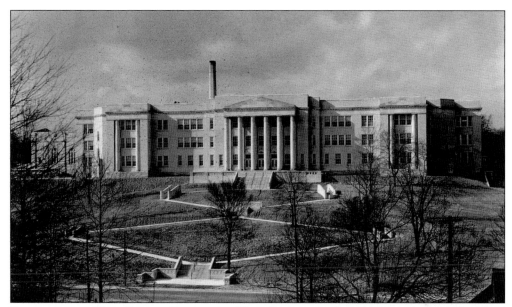

BARRET JUNIOR HIGH SCHOOL COMPLETED. The school was built on a hill overlooking Grinstead Drive, and when it was completed, it was a most imposing presence to passersby. Originally named Crescent Hill Junior High School, the name was changed in May 1932 to Alexander G. Barret Junior High School, to honor a former president of the board of education. In 1986, Barret became a traditional middle school within the county school system. (Courtesy of JCPS.)

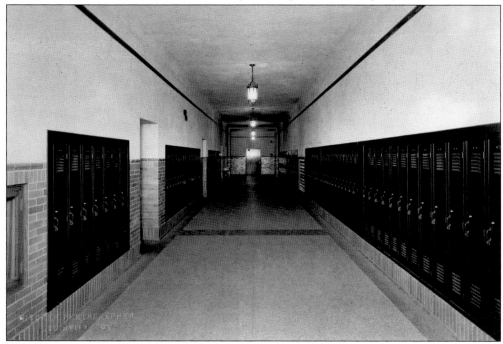

BARRET JUNIOR HIGH SCHOOL, INTERIOR. One can imagine that a major construction project like this school in 1931, which was a bad Depression year, provided many jobs for men out of work. This photograph, taken upon the completion of the school, shows a spotless hallway in an almost abstract image. (Courtesy of JCPS.)

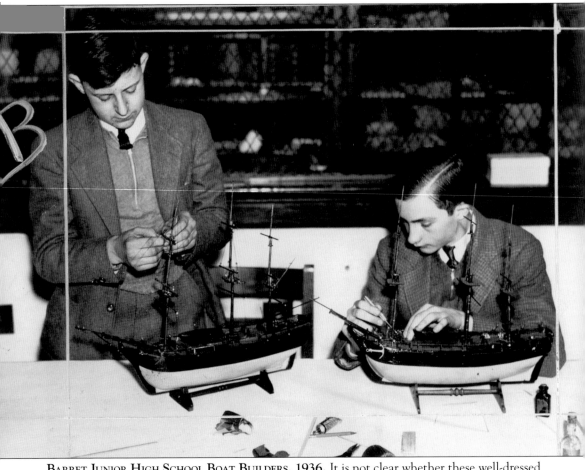

BARRET JUNIOR HIGH SCHOOL BOAT BUILDERS, 1936. It is not clear whether these well-dressed Barret students are working on their model boats for a science fair or for hobby purposes, but it is clear that they are taking their work very seriously. (Courtesy of JCPS.)

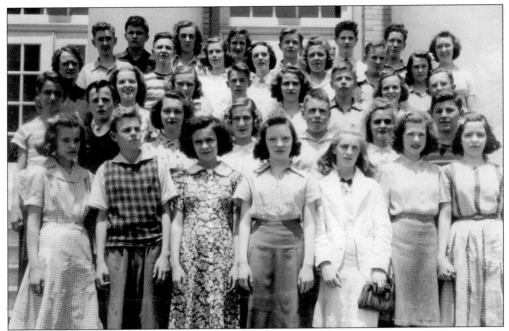

BARRET JUNIOR HIGH SCHOOL, CLASS OF 1940. This photograph shows 36 members of Barret's class of 1940, although the purpose of the picture is not known. Since Barret had about 400 students enrolled at this time, it is clear that this is not the entire 1940 class but perhaps just a homeroom. (Courtesy of Mary Bateman.)

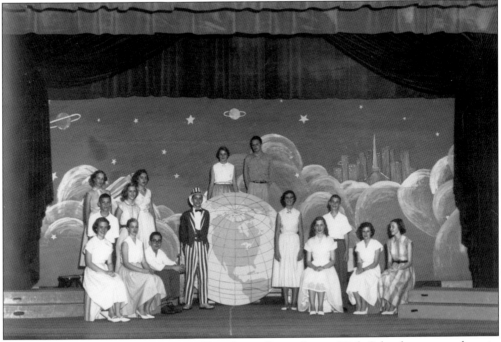

BARRET SCHOOL, CLASS DAY, 1953. Class day at Barret Junior High School meant, at least in 1953, a pageant performed in the school auditorium. For this year, the theme was clearly focused on patriotism and, in all likelihood, the ominous presence of the Cold War. (Courtesy of JCPS.)

CHENOWETH ELEMENTARY SCHOOL, ENTRANCE. Chenoweth, the newest school in Crescent Hill, is located on Country Lane, a short street on the south side of Brownsboro Road in the northeast corner of Crescent Hill. The school was built in 1954 on land purchased from the Masonic Widows and Orphans Home at a cost of $493,000. It was named for John Henry Chenoweth (1825–1905), a well-known doctor who lived on what is now Chenoweth Lane. The school suffered substantial damage in the April 1974 tornado, and students had to finish the school year at Crosby Middle School. (Courtesy of Chenoweth School.)

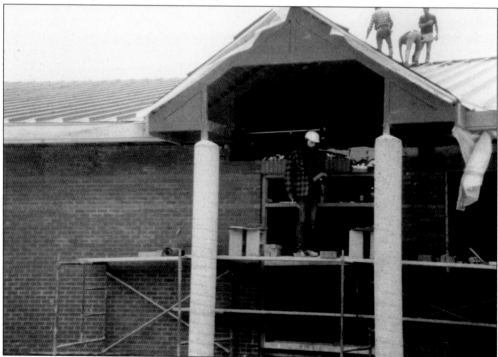

CHENOWETH ELEMENTARY SCHOOL CONSTRUCTION, 1995. In the summer of 1995, an addition consisting of four classrooms, a science lab, a media center, and a family resource center was completed. It was named the Irwin-Morrison wing in honor of two former staff members. (Courtesy of Chenoweth School.)

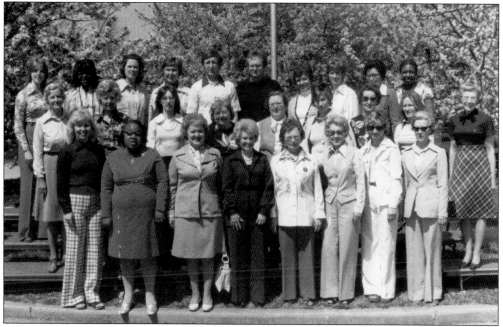

CHENOWETH ELEMENTARY SCHOOL STAFF, 1975 TO 1976. This photograph shows the faculty and staff of Chenoweth in the 1975 to 1976 school year. The principal, Marguerite Lewis, who was finishing her final year in the job, is in the center of the front row. (Courtesy of Chenoweth School.)

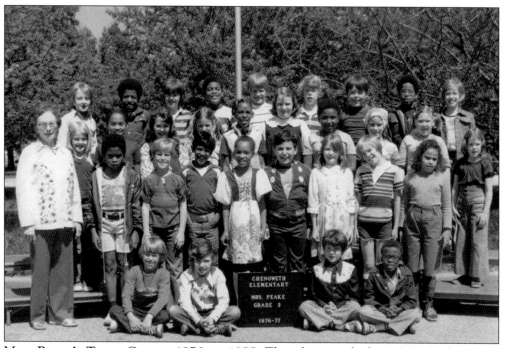

MRS. PEAKE'S THIRD GRADE, 1976 TO 1977. This photograph shows Mrs. Peake's third grade class at Chenoweth Elementary School in the 1976–1977 school year. (Courtesy of Chenoweth School.)

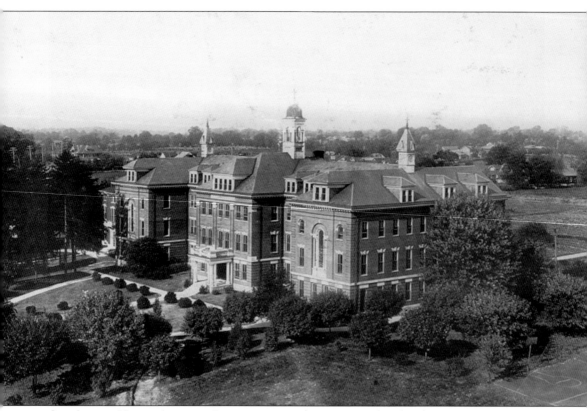

OLD SACRED HEART ACADEMY BUILDING. Cornelius Curtin, who also designed the St. Joseph Children's Home, was the architect for the Sacred Heart Academy building, which opened in 1904. Unfortunately, the building was destroyed in a spectacular fire in April 1918, which attracted onlookers from all over the city. The cause of the fire was never officially determined, and the loss was estimated at $200,000. A new Sacred Heart Academy building was completed in 1926, and classes met in the Ursuline Motherhouse in the interim. (Courtesy of USHA.)

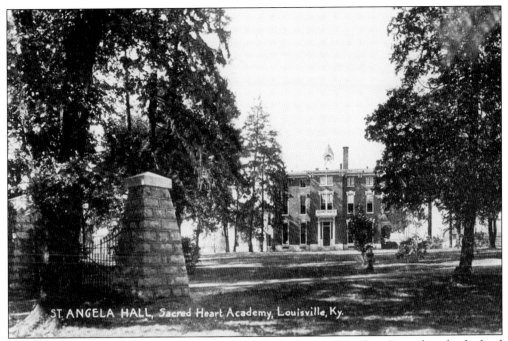

ST. ANGELA HALL, Sacred Heart Academy, Louisville, Ky.

ST. ANGELA HALL, SACRED HEART ACADEMY. In 1877, when the Ursuline Sisters bought the land along the Shelbyville Branch Turnpike (present-day Lexington Road) a three-story house was on the property. It was named St. Angela Hall and was used as the Sacred Heart Academy School until 1904, when the building on the preceding page was opened. By 1887, a two-story wing was added to provide boarding school facilities. (Courtesy of USHA.)

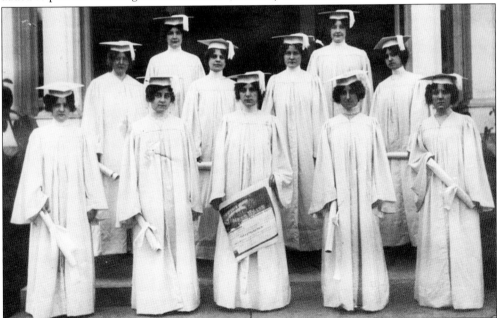

SACRED HEART ACADEMY GRADUATES, 1914. This photograph shows the members of Sacred Heart's graduating class of 1914. The white robes appear to have been customary throughout the academy's history. (Courtesy of USHA.)

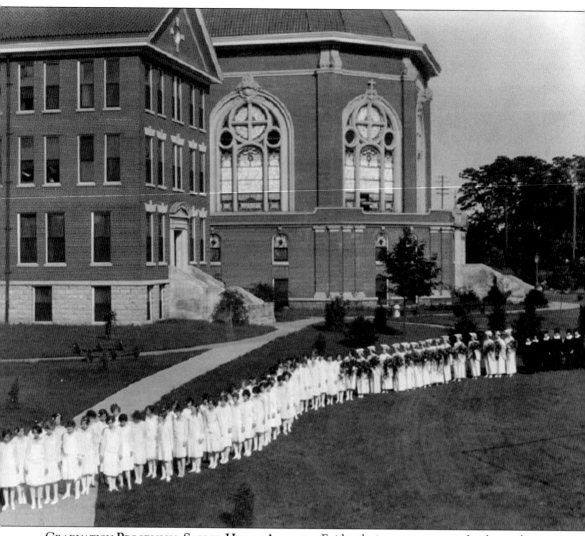

GRADUATION PROCESSION, SACRED HEART ACADEMY. Evidently, it was customary for the student body and the faculty to parade across campus as part of the commencement ceremony. This c. 1920 photograph shows the students and faculty proceeding away from the Motherhouse toward a possible outdoor venue for the ceremonies. (Courtesy of USHA.)

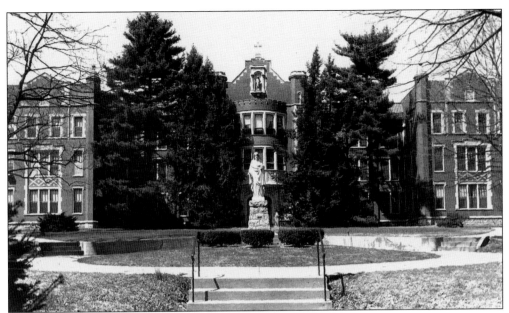

NEW SACRED HEART ACADEMY BUILDING, 1926. After the 1918 fire destroyed the main building of Sacred Heart Academy, Fred J. Erhart, the architect who designed the Ursuline Motherhouse, was commissioned to design a new academy building. He used a Tudor Gothic style and the building was completed in 1926. It now houses the Sacred Heart Model School. (Courtesy of the author.)

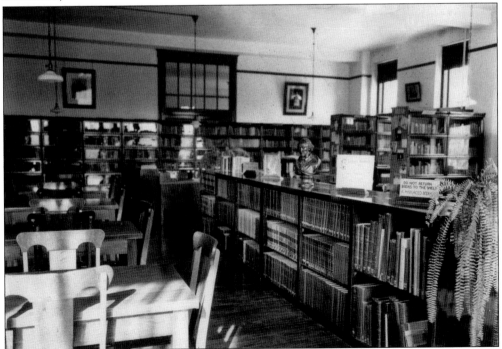

SACRED HEART ACADEMY LIBRARY. This library served as the academy's main library from 1926 to 1955, when a new facility was built. It was then made into an art room and is now used for office space. (Courtesy of KHC.)

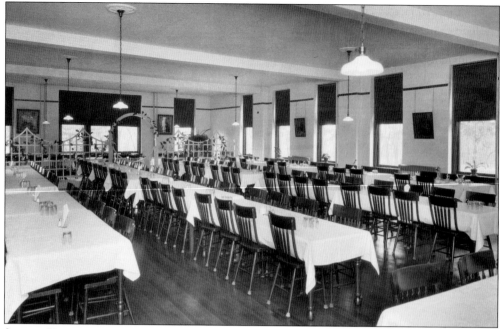

SACRED HEART ACADEMY DINING ROOM. This photograph of the new Sacred Heart Academy building that opened in 1926, suggests that it was, for its time, a modern and well-appointed facility. The academy was a boarding school until the early 1940s, so ample dining space was needed. (Courtesy of USHA.)

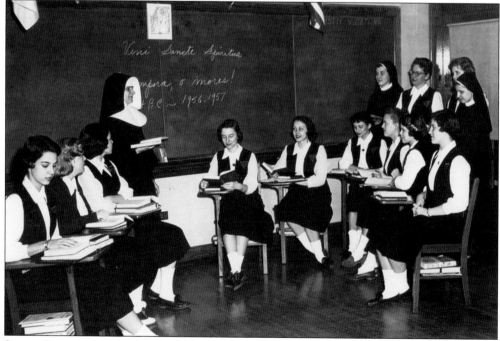

SISTER ALPHONSINE'S LATIN CLASS. Sacred Heart had a dedicated faculty that, until the 1970s, was composed mostly of Ursuline Sisters. Now lay faculty comprise a majority of the instructional staff. This photograph shows a Latin class from the 1950s. (Courtesy of USHA.)

SACRED HEART MODEL SCHOOL. The Sacred Heart Model School was created in 1924 and was housed in Angela Hall, the original house on the campus. In 1955, a new building, also called Angela Hall, was built at a cost of $165,000, with classes for kindergarten through eighth grade. In 1999, the Model School moved into the 1926 Sacred Heart Academy building. (Courtesy of USHA.)

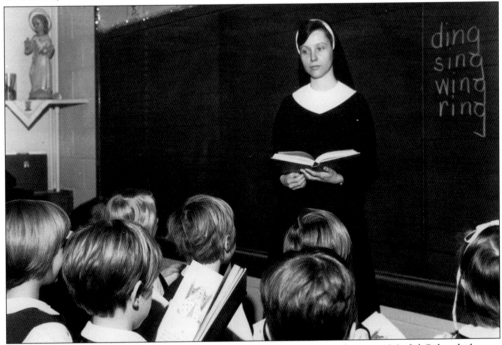

SISTER SHARON'S FIRST-YEAR READING CLASS. While sisters taught some Model School classes, the purpose of the Model School was to serve Ursuline College as a teaching laboratory. In 1959, for example, a new math system was introduced into the school curriculum. Ursuline College is now part of Bellarmine University. (Courtesy of USHA; photograph by Andrew G. Thorne.)

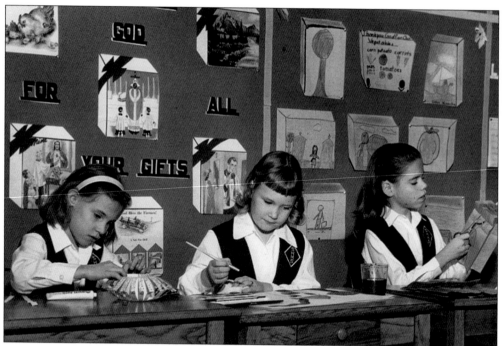

SACRED HEART MODEL SCHOOL FIRST GRADE. Model School students were, for most of the history of the school, coed and did not wear uniforms. This photograph shows a first-grade art class in the 1960s. (Courtesy of USHA; photograph by Andrew G. Thorne.)

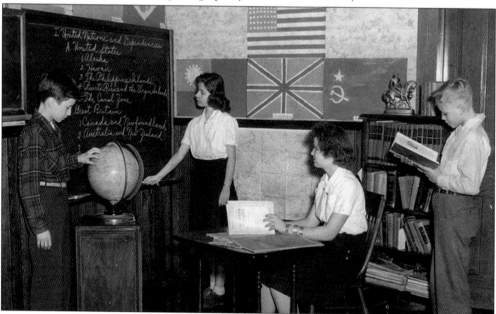

SACRED HEART MODEL SCHOOL SOCIAL STUDIES CLASS. In 1969, acting on complaints of some older students, the Model School was divided into a kindergarten through fifth-grade section and a sixth- through eighth-grade section, with each section housed in a separate building. This is a photograph of an eighth-grade social studies class from the Cold War era. (Courtesy of USHA; photograph by Charles Keyes.)

Four

CHURCHES

CRESCENT HILL PRESBYTERIAN CHURCH. Located at 142 Crescent Avenue, the Crescent Hill Presbyterian Church was built in 1891, a year after the congregation was organized. The first minister was B. Lewis Hobson, who served from 1890 to 1893. This photograph shows the church after a major renovation in 1937, designed by Herbert E. Redman, that extended the front of the church and created a new entryway. (Courtesy of CHPC.)

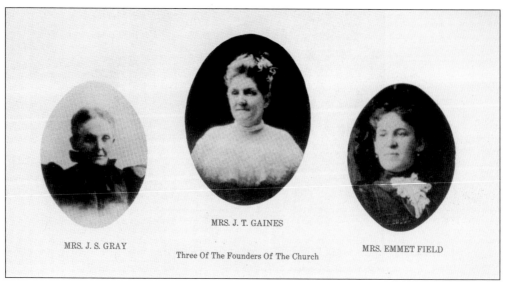

MRS. J. T. GAINES

MRS. J. S. GRAY

Three Of The Founders Of The Church

MRS. EMMET FIELD

CRESCENT HILL PRESBYTERIAN FOUNDERS. This photograph shows Fannie Barber Gray, Cordelia R. Green, and Susan F. Field, all of whom were instrumental in the establishment of the Crescent Hill Presbyterian Church in 1890. (Courtesy of CHPC.)

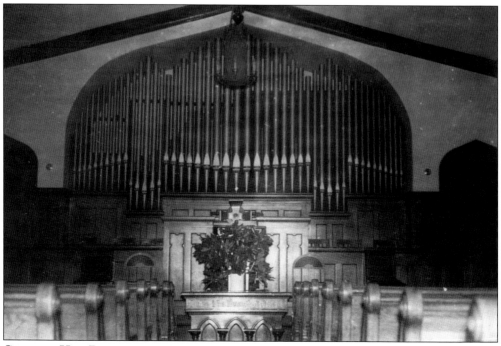

CRESCENT HILL PRESBYTERIAN CHURCH SANCTUARY. This photograph shows the commodious sanctuary of the church after the 1937 renovation. A 1955 survey that a group of University of Louisville students completed for the church noted that it had 569 members, as well as Boy Scout and Girl Scout troops and a Cub Scout pack. (Courtesy of CHPC.)

CRESCENT HILL PRESBYTERIAN CHURCH EDUCATION BUILDING. Since the church's early days, there had been a small building for Sunday school classes and a public tennis court behind the church. Around 1949, a new education building was erected, containing a small auditorium with a stage, a kitchen, and a meeting room. It was, and still is, used for a variety of social and cultural purposes. (Courtesy of CHPC.)

THE REVEREND J. HARVEY GLASS, PRESBYTERIAN MINISTER. Glass was the church's 10th minister, serving the congregation from 1951 to 1957 and overseeing the construction of the education building. (Courtesy of CHPC.)

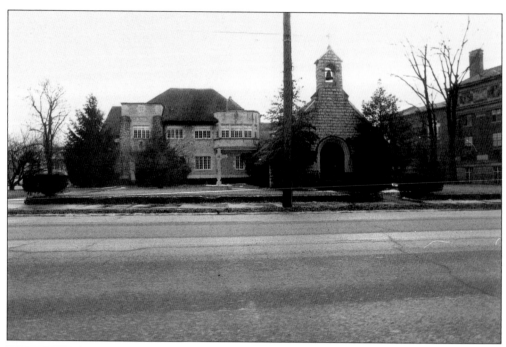

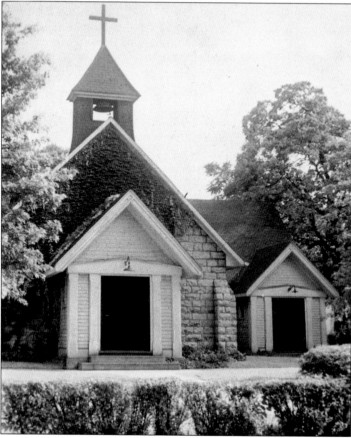

ST. MARK'S EPISCOPAL CHURCH, C. 1920. St. Mark's began as an Episcopalian mission in 1891, but land for a permanent church was acquired in 1894, the cornerstone was laid in 1895, and the first service was held in June 1895. A.P. McDonald designed the church in the popular Gothic Revival style. This c. 1920 photograph shows the church after a major addition in 1908. (Courtesy of SMEC.)

ST. MARK'S EPISCOPAL CHURCH, C. 1955. This photograph from the 1950s shows St. Mark's after the building of a large parish house in 1924 and another addition to the main church building in 1949. (Courtesy of CHPC.)

ST. MARK'S EPISCOPAL CHURCH, REV. RICHARD L. McCREADY. Richard McCready was the first permanent minister at St. Mark's, serving from 1906 to 1917. Under his leadership, the church completed a major addition in 1908 that included a chancel, east and west transepts, and it became self-supporting. (Courtesy of SMEC.)

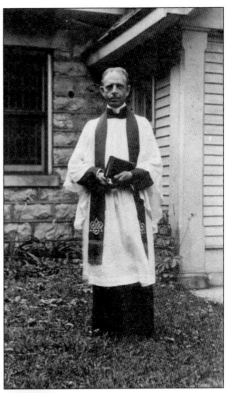

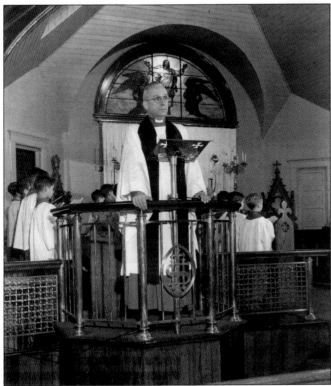

REV. WILLIAM H. LANGLEY IN THE PULPIT, 1947. William H. Langley served the congregation from 1934 to 1969 at St. Mark's Episcopal Church. In 1949, he oversaw the expansion that enlarged the sanctuary by 20 feet and included additional second-floor space for Sunday school rooms. (Courtesy of SMEC.)

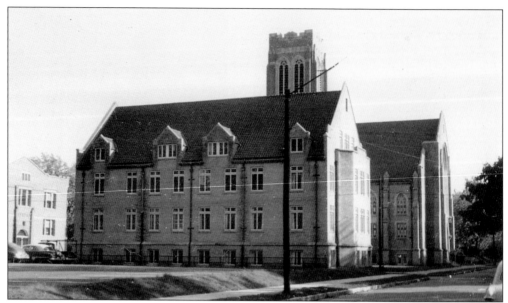

CRESCENT HILL UNITED METHODIST CHURCH. In 1887, the Crescent Hill United Methodist Church was established and met in a schoolhouse on Crescent Avenue until a church was constructed in 1890, at the southeast corner of Frankfort and Raymond (now Ewing) Avenues. The church shown in this photograph is located on South Peterson Avenue just south of Frankfort, and was dedicated in 1927. Later, the older congregation disbanded and many of its members began coming to the church on Peterson. (Courtesy CHPC.)

CRESCENT HILL UNITED METHODIST CHURCH RETIREMENT DINNER. This c. 1957 photograph from the retirement dinner is undated and the people are unidentified, but it was most likely taken on the occasion of the retirement of Rev. A.W. Beasley. He was the predecessor to Rev. Reid Thompson, who served the church from 1957 to 1989. (Courtesy of CHUMC.)

CRESCENT HILL UNITED METHODIST CHURCH, SUSANNAH WESLEY CLASS, 1952. This photograph shows the members of the Susannah Wesley class of 1952. Wesley was the mother of John Wesley, the founder of the Methodist denomination. Susannah Wesley classes attracted women who were interested in religious education and social service. (Courtesy of CHUMC.)

CRESCENT HILL UNITED METHODIST CHURCH CHOIR. This 1950s photograph shows the choir singing from the choir loft in the church chancel. (Courtesy of CHUMC.)

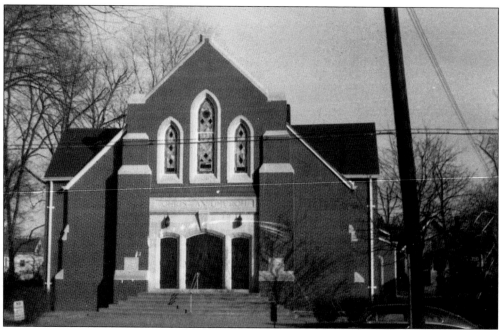

CRESCENT HILL CHRISTIAN CHURCH. Located at 117 Crescent Avenue, this church was originally built as a country schoolhouse, but was later donated by Sen. S.S. English for religious education. It was used on Sunday mornings for Presbyterian services and on Sunday afternoons for Episcopalian services. Friday night dances were also popular. The frame schoolhouse was incorporated into the Crescent Hill Christian Church in 1913, when a brick Sunday school addition was completed. In 1923, the frame structure was razed to allow for a new brick sanctuary that is seen in this photograph. (Courtesy of CHPC.)

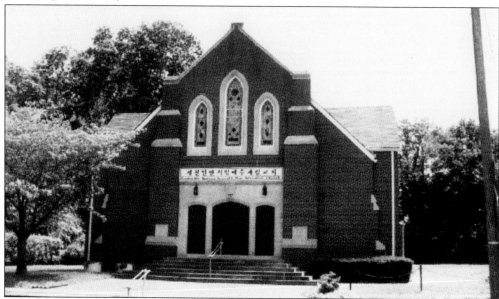

LOUISVILLE KOREAN 7TH DAY ADVENTIST CHURCH. Beset by falling membership, the Crescent Hill Christian Church closed in 1993, and the building became the home of the Louisville Korean 7th Day Adventist Church in 1995. (Courtesy of the author.)

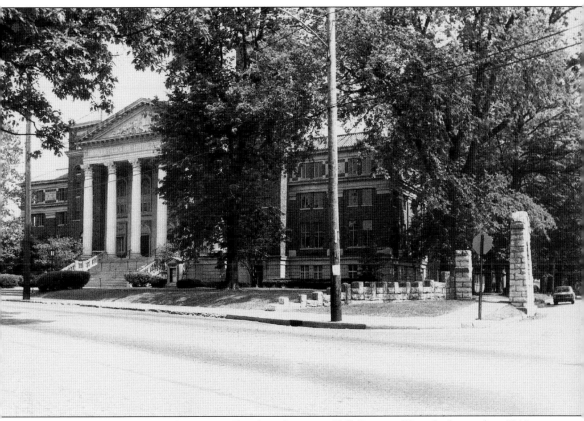

CRESCENT HILL BAPTIST CHURCH. The first Crescent Hill Baptist Church, located at 2810 Frankfort Avenue, was built c. 1908 in a Classical Revival style, but the congregation soon outgrew it. In 1926, Otto D. Mock designed this Greek Revival structure that replaced the older church. By 1955, the church counted more than 2,300 members, and an extensive three-story addition in back of the sanctuary was built in 1957. It included a gym, craft and game rooms, a chapel, a pastor's study, and even a bride's room. (Courtesy of CHPC.)

CRESCENT HILL BAPTIST CHURCH SUNDAY SCHOOL CLASS, 1910. This photograph shows one of the first Sunday school classes at the Crescent Hill Baptist Church. (Courtesy of CHBC.)

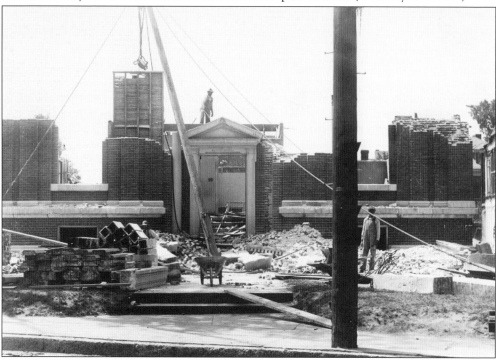

OLD CRESCENT HILL BAPTIST CHURCH UNDER DEMOLITION. Since the new church was to be built at the same location as the old church, it was necessary to tear down the old one, and this 1925 or 1926 photograph shows part of that process. (Courtesy of CHBC.)

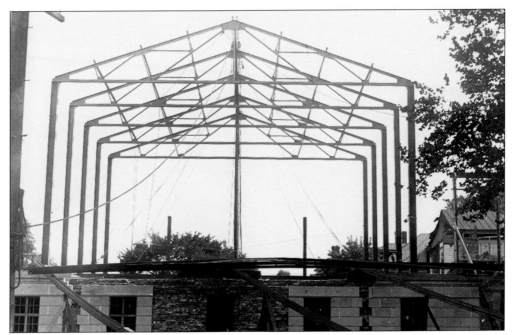

NEW CRESCENT HILL BAPTIST CHURCH UNDER CONSTRUCTION, 1926. This photograph, taken a few months after the preceding one, gives an indication of the much larger size of the new Crescent Hill Baptist church. (Courtesy of CHBC.)

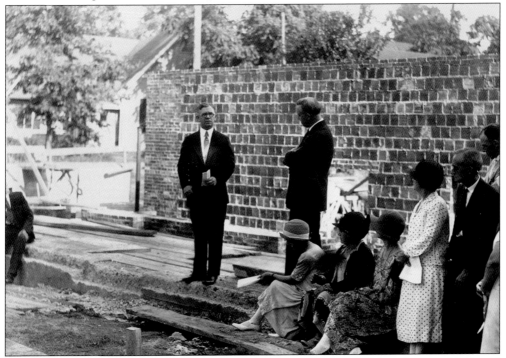

SPEAKER AT CHURCH CONSTRUCTION. This 1926 photograph taken during the construction of the new Crescent Hill Baptist Church shows Thomas "T.J." Johnson (left) and the chairman of deacons of the church speaking at the construction site. (Courtesy of CHBC.)

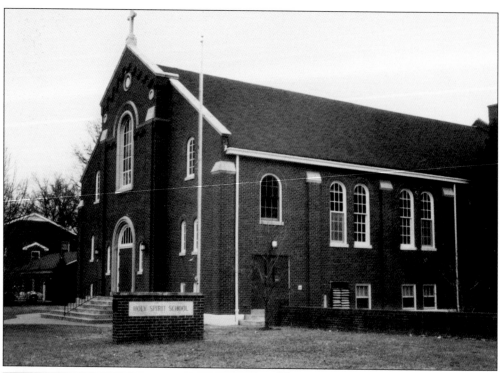

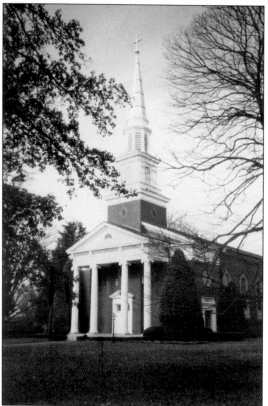

HOLY SPIRIT CATHOLIC CHURCH, 1937. The archdiocese approved the creation of the Holy Spirit parish in 1936, and purchased land at the corner of Lexington Road and Cannons Lane. Fr. John W. Vance began work as the parish priest in early 1937, and found himself helping flood refugees almost immediately. He oversaw the construction of a church building facing Cannons Lane that was dedicated in January 1938. (Courtesy of Holy Spirit Catholic Church.)

HOLY SPIRIT CATHOLIC CHURCH, 1954. By the mid-1950s, the parish numbered 800 families and 550 school children, and the need for a new church was acute. As this photograph shows, a much larger building was erected at a cost of nearly $570,000 that was similar in style to one in Bardstown. The old church became part of the parish school. Father Vance was still the parish priest and continued in that post until 1970. (Courtesy of Holy Spirit Catholic Church.)

Five

CHARITABLE HOMES
AND INSTITUTIONS

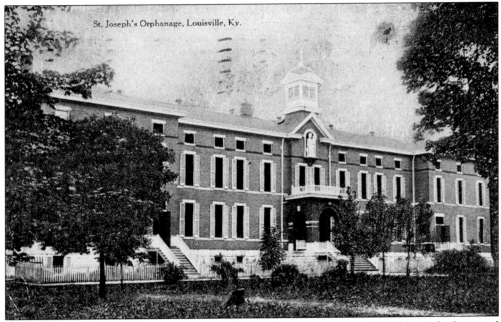

ST. JOSEPH'S CHILDREN'S HOME. Architect Cornelius Curtin designed this building, which opened as the St. Joseph Catholic Orphans Home in 1886. "St. Joe's," as it is popularly known, had been established in 1849, and operated in two other locations before moving to former fairgrounds land along Frankfort Avenue in the 1880s. Joseph P. Taylor, brother of the former president Zachary Taylor, once owned some of this land. (Courtesy of the author.)

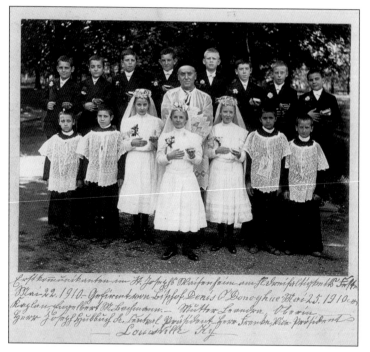

ST. JOSEPH'S CHILDREN, 1910 CLASS. This photograph taken in March 1910, shows us eight older boys in the back, all dressed in suits, four younger boys in front, dressed perhaps as altar boys, and three girls in the front center who look ready for their First Communion. In the middle of the group is a priest. Apart from a First Communion ceremony, it is unknown what the purpose of this gathering was, and the writing below, in an obscure European language, is not helpful. (Courtesy of SJCH.)

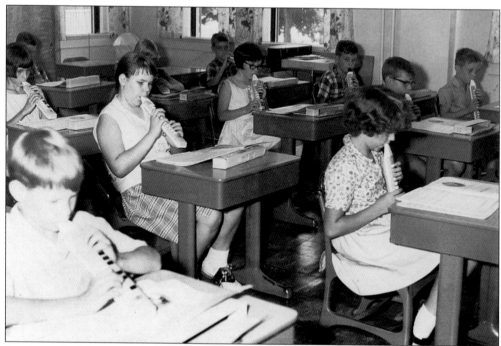

ST. JOSEPH'S, MELODICA CLASS, C. 1960. A melodica appears to be a simple plastic musical instrument that is played like a simplified clarinet. It almost certainly did not produce concert-grade music, but it was useful in teaching students some music fundamentals and starting them on the path to reading music. (Courtesy of SJCH.)

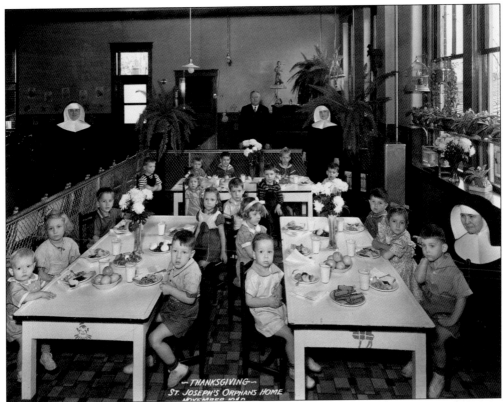

St. Joseph's, Thanksgiving, 1940. This photograph taken at Thanksgiving in 1940 shows the youngest children at St. Joe's being treated to a traditional Thanksgiving dinner. Observance of traditional holidays must have been important to children who were without families with whom to celebrate. (Courtesy of SJCH.)

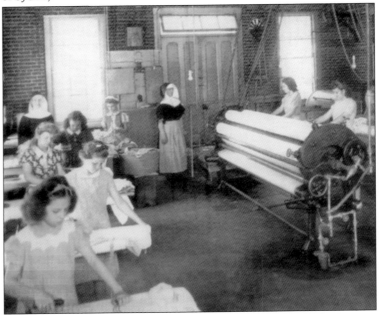

St. Joseph's, Girls in Laundry, c. 1950. This photograph shows some St. Joe's girls working in the institution laundry, probably around 1950. Although some protested that this was exploitative, school officials replied that everyone at St. Joe's had to do various chores. (Courtesy of SJCH.)

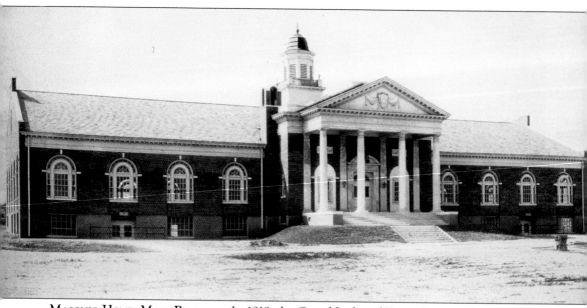

MASONIC HOME, MAIN BUILDING. In 1919, the Grand Lodge of Kentucky created the "Million Dollar" Committee to raise funds for a new Masonic Widows and Orphans Home to replace the one that was opened in 1871 and was badly outdated. Their efforts were successful. A large parcel of land on Frankfort Avenue east of Fenley Avenue was acquired, construction began in 1925, and the home opened in 1927. The local architectural firm of Joseph and Joseph designed the buildings, and the firm of Platoff and Bush did the construction work. This photograph shows the main building at the new Frankfort Avenue campus. In 1989, the Masonic Home was converted into a retirement community. (Courtesy of MHK.)

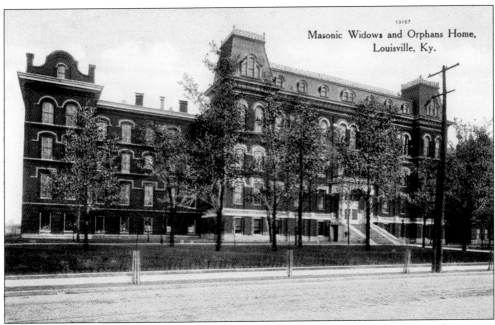

Masonic Widows and Orphans Home, Louisville, Ky.

OLD MASONIC WIDOWS AND ORPHANS HOME. Located at Second and Lee Streets in what is now known as Old Louisville, the Masonic Widows and Orphans Home was chartered by the state in 1867. T.C. Shrieve donated the land for this building in 1868, and the first child was admitted in 1871, although the facility was not completed. It was the first such institution in the United States. In 1917, there were 26 widows and 347 children living there. This building remained in use until the opening of the new campus on Frankfort Avenue in 1927 and has since been razed. (Courtesy of the author.)

MASONIC HOMES OF KENTUCKY, ENTRANCE. This photograph shows the entrance to the new home on Frankfort Avenue. Standing at the entrance are Lee Cralle Sr., the president of the board of directors at the time, and his wife. The Cralle family had been in the funeral home business for many years (see page 83). (Courtesy of MHK.)

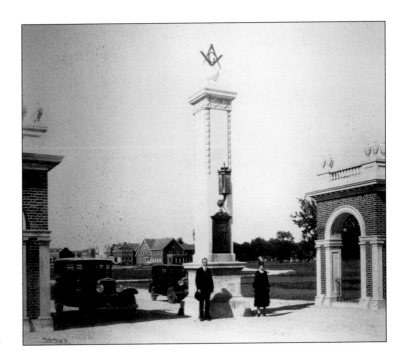

MASONIC HOME, GARNETT HALL. Garnett Hall was the principal classroom building at the Masonic Home. It was named for James Garnett, who served as chairman of the building committee and had been the board of directors's attorney since 1918. He served as president of the board from 1934 until his death in 1939 and also had a long and distinguished career in the state Masonic organization. Garnett and his wife are pictured here standing in front of the school. After the closing of the educational program, the building was converted into apartments. (Courtesy of MHK.)

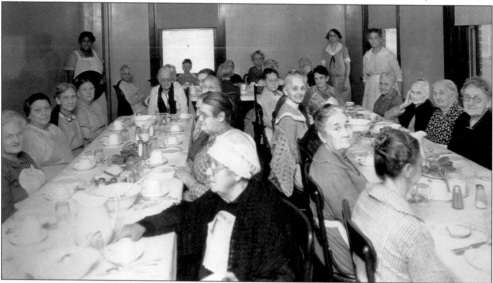

MASONIC HOME, WIDOWS' DINING ROOM. When the new Masonic Widows and Orphans Home opened in 1927, some 35 widows moved from the old home to a cottage called the Widows Building. This 1927 photograph shows most of them in their dining room. As the years passed, more widows came to the Masonic Home, and by the end of the 1970s, approximately 220 widows were in residence. (Courtesy of MHK.)

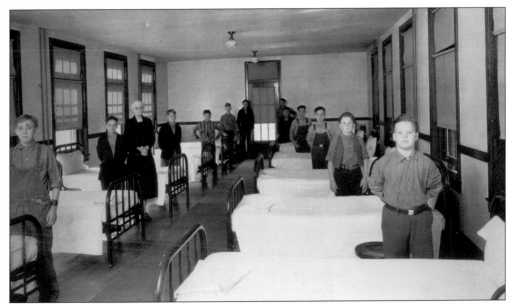

MASONIC HOME, BOYS DORMITORY. Boys at the Masonic Home in 1927 lived in cottages one through four. The younger boys were housed in cottages two and three, the intermediate boys were in cottage four, and the oldest boys were in cottage one. Girls lived in cottages five through eight, identically laid out on the opposite side of the campus. This photograph from the early years at the home is probably the dormitory in cottage four, given the age of the boys. (Courtesy of MHK.)

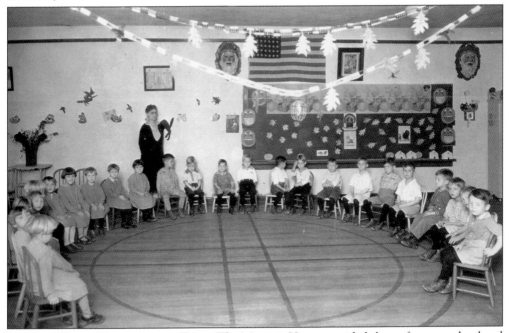

MASONIC HOME, KINDERGARTEN CLASS. The Masonic Home provided classes from preschool and kindergarten through the 10th grade for the nearly 600 children who were in residence during the early years on Frankfort Avenue. Under the effective leadership of Belle Ford, the principal, the school was said to be among the best in the state. (Courtesy of MHK.)

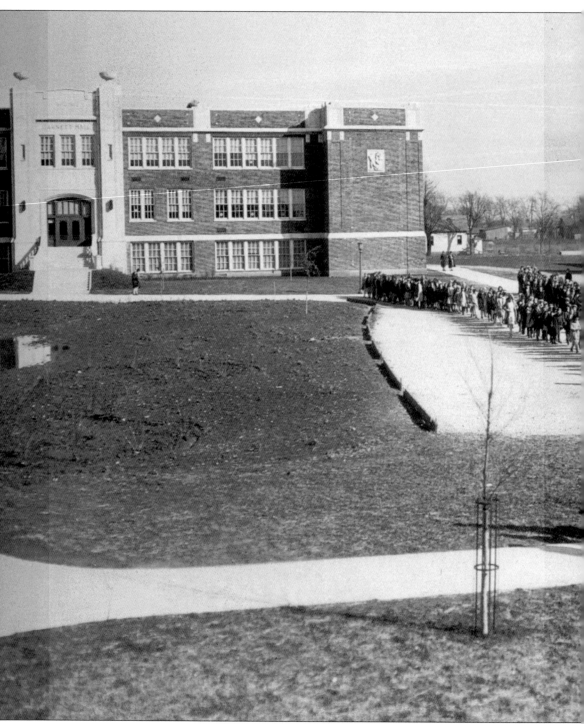

MASONIC HOME, PARADE OF CHILDREN. Children at the Masonic Home lived a fairly regimented and disciplined life. After rising at 6:00 a.m. and having breakfast, they attended a short religious service in the auditorium and marched in a double file to Garnett Hall for their classes. After morning classes, they marched over to the main building for lunch. Girls entered on one side of

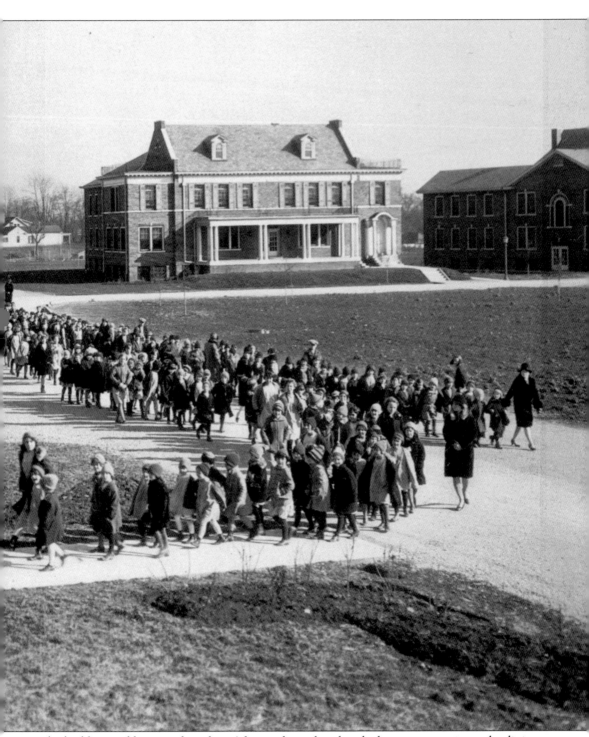

the building and boys on the other. After washing their hands they went upstairs to the dining room. This photograph not only shows the children parading to lunch from Garnett Hall, but it also gives a view of part of the campus layout. (Courtesy of MHK.)

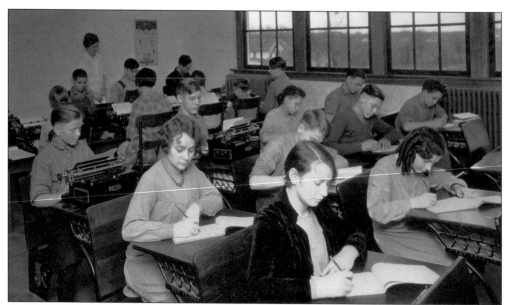

MASONIC HOME, JUNIOR HIGH SCHOOL CLASS. Over the years, the number of children living at the Masonic Home steadily declined. This 1920s photograph shows a ninth- or tenth-grade class. In 1947, the school was expanded to include 11th and 12th grades, and the first graduating class, which had 11 students, received diplomas in 1949. However, enrollment continued to fall and the school program was discontinued after 1954, with the remaining children sent to Jefferson County Public Schools. (Courtesy of MHK.)

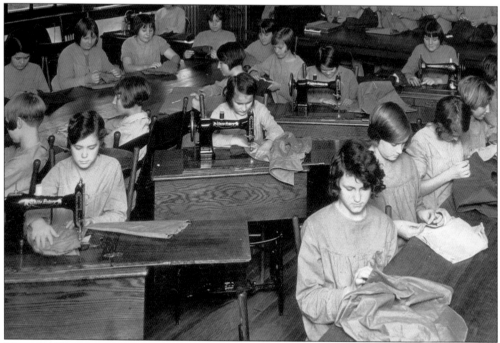

MASONIC HOME, GIRLS SEWING CLASS. Many girls at the Masonic Home learned sewing skills in a special sewing room. There they made the uniform dresses that they regularly wore and also made or repaired clothes for the widows at the home. (Courtesy of MHK.)

MASONIC HOME, STUDENT-BUILT HOUSE. In 1932, when plans were announced to build an employees' house on nearby Washington Avenue, students in the manual training class asked if they could do the work under the supervision of Frank Dixon, their instructor. They received permission and built the house between October 1933 and June 1934 at a cost of just over $8,300. They did all the work except for plumbing, electricity, plastering, and the chimney. The house is still owned and used by the Masonic Homes. (Courtesy of MHK.)

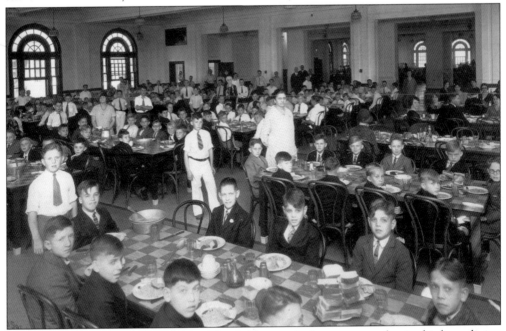

MASONIC HOME, MAIN DINING HALL. The children at the home ate together in this large dining room located in the main building at the center of the campus. The building is now called The Olmsted and is used for community events, wedding receptions, and similar events. (Courtesy of MHK.)

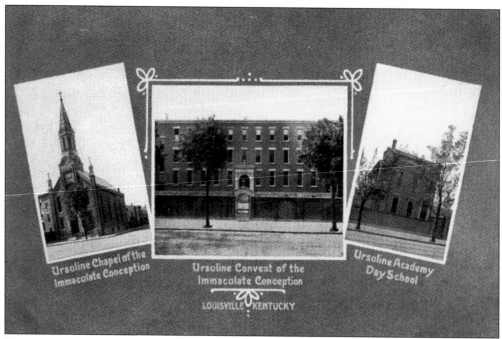

URSULINE, A MULTIVIEW POSTCARD. This early c. 1905 postcard image shows three buildings that served the Ursuline community at its original downtown location at Chestnut and Shelby Streets before all of its operations were moved to the Lexington Road site. The postcard shows the Ursuline Motherhouse (or convent), where the sisters lived; the chapel, where they prayed; and the day school where they taught. All of these buildings date from the 1860s or 1870s, and none survive today. (Courtesy of the author.)

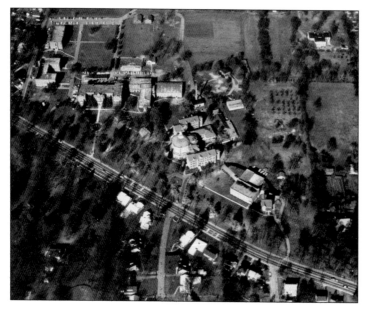

AERIAL VIEW, URSULINE CONVENT AND SACRED HEART ACADEMY. This bird's-eye view of the Ursuline campus on Lexington Road shows the Motherhouse in the center and Sacred Heart Academy's 1926 building above and to the left. The newer Sacred Heart facilities can be seen still farther to the left. Lexington Road runs along the bottom of the photograph. This photograph was taken in 1961. (Courtesy of USHA; photograph by Robert Steinau.)

URSULINE AND SACRED HEART ENTRANCE. This stone entry gate faces Lexington Road at the main entrance to the campus. In the background is the Sacred Heart Academy building (see page 45). (Courtesy of USHA.)

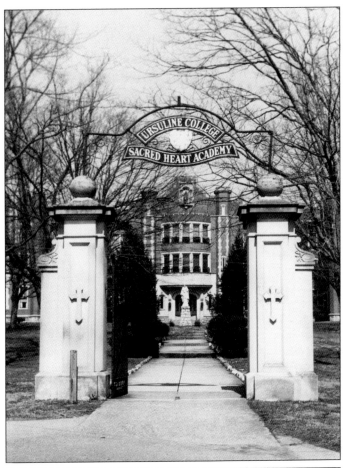

URSULINE MOTHERHOUSE. The center of activity for the Ursuline Sisters, the Motherhouse, is located on the campus at 3115 Lexington Road. The elaborate classical structure with its Baroque central section, designed by Fred J. Erhart, was dedicated on what was said to be the coldest day in Louisville history in December 1917. In 1976, fire severely damaged the building, parts of which were closed for a year. (Courtesy of USHA.)

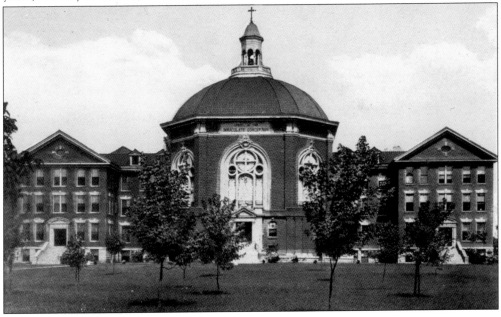

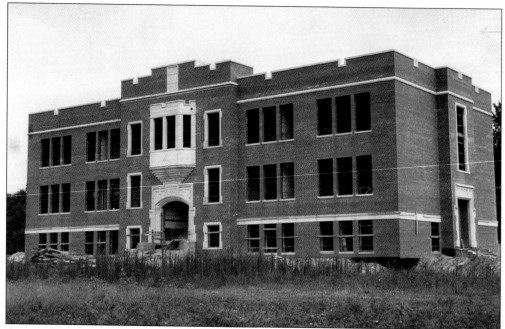

BRESCIA HALL, URSULINE COLLEGE. Sacred Heart Junior College opened in 1921 to train sisters for teaching at parochial schools across the country. In 1938, it was renamed Ursuline College and the college moved to the newly built Brescia Hall in 1940. This photograph shows Brescia Hall when it was not quite completed. (Courtesy of USHA.)

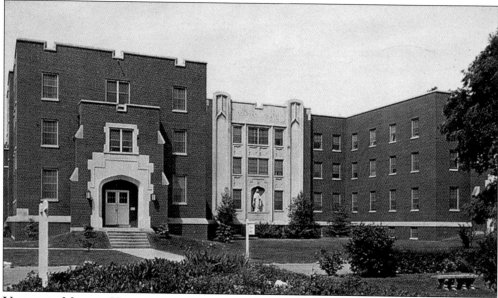

URSULINE, MARIAN HALL. This building was constructed in the 1950s, not long after the old Angela Hall was razed. It was designed as a residence hall for Ursuline College students and contained a chapel, library, dining room, and offices. In 1977, Marian Hall was remodeled to become a licensed nursing facility for Ursuline Sisters. Another college dorm, Julianne Hall, had opened in 1962; it was once Woodcock Hall, an Episcopal orphanage for boys. It was torn down in 1998 to make room for a parking lot. (Courtesy of USHA.)

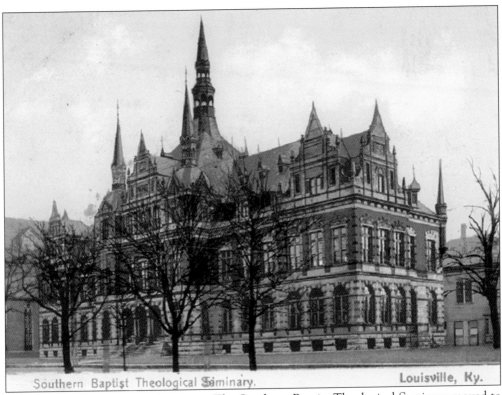

Southern Baptist Theological Seminary. Louisville, Ky.

OLD BAPTIST THEOLOGICAL SEMINARY. The Southern Baptist Theological Seminary moved to Louisville from South Carolina in 1873, but financial difficulties prevented the construction of this seminary building called New York Hall, until 1888. Located in downtown Louisville on Broadway between Fifth and Sixth Avenues, the seminary added a library building in 1891 and a classroom building in 1893 called Norton Hall. This campus served the seminary until it moved to Lexington Road in the 1920s. The buildings on Broadway were demolished in the 1930s. (Courtesy of the author.)

SOUTHERN BAPTIST THEOLOGICAL SEMINARY, MULLINS AT GROUNDBREAKING. As early as 1909, seminary trustees decided that the site on Broadway was too small for their needs, and Louisville's commercial growth precluded any expansion there. By 1915, seminary president E.Y. Mullins declared the situation to be a great emergency. In 1923, the seminary bought 50 acres of land on Lexington Road, and New York architect James Gamble Rogers was chosen to design a new campus. This photograph shows Mullins at the groundbreaking ceremony in October 1923. (Courtesy of SBTS.)

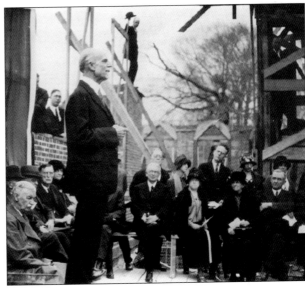

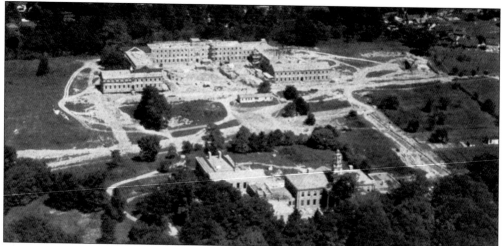

SOUTHERN BAPTIST THEOLOGICAL SEMINARY UNDER CONSTRUCTION, 1925. This 1925 postcard shows a bird's-eye view of the construction of the new seminary. Interestingly, it was mailed to a person from Louisville with a printed message and signature from E.Y. Mullins, who wrote that he thought the recipient, a donor, presumably, would like to see the progress of the building of the new campus. (Courtesy of the author.)

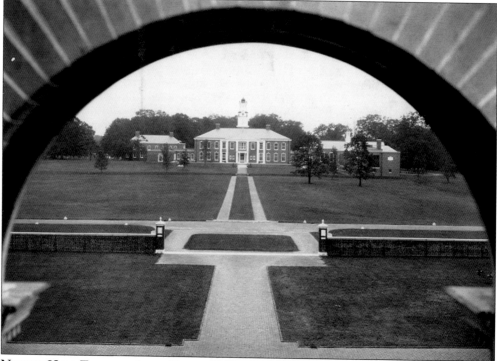

NORTON HALL THROUGH ARCH. Norton Hall at the Southern Baptist Theological Seminary was the main administration building and the aesthetic centerpiece for the seminary's new campus, The Beeches. The architect was James Gamble Rogers, and the ground-breaking took place on May 28, 1924. Rogers had a much more elaborate campus in mind, but seminary president E.Y. Mullins argued that it would be too ostentatious to suit the majority of Southern Baptists. (Courtesy of SBTS.)

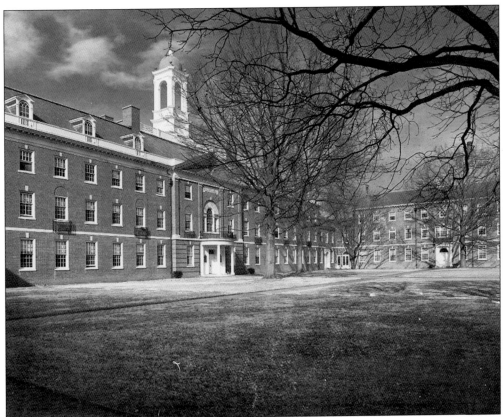

SOUTHERN BAPTIST THEOLOGICAL SEMINARY, CAMPUS QUADRANGLE. The seminary moved from downtown Louisville to the Lexington Road campus in March 1926. It was a beautiful site—the Olmsted Brothers firm did the landscaping, with classically styled buildings, but it saddled the seminary with a substantial debt that remained a burden for years. (Courtesy of SBTS.)

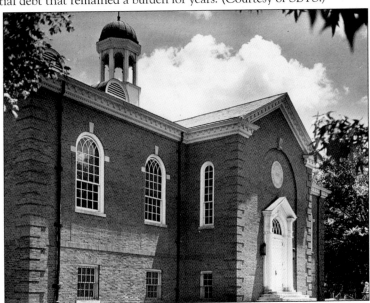

SOUTHERN BAPTIST THEOLOGICAL SEMINARY, LEVERING GYM. Named for Joshua Levering, long-time chairman of the board of trustees, this gym replaced one of the same name that had served the seminary at its downtown location. (Courtesy of SBTS.)

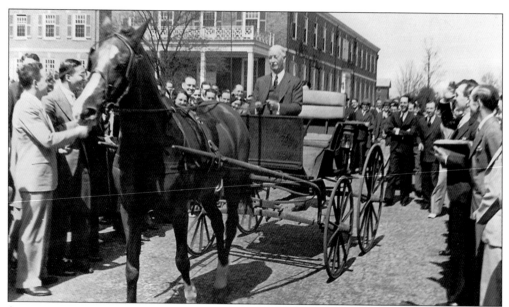

SAMPEY DRIVING HORSE-AND-BUGGY. John R. Sampey succeeded E.Y. Mullins as president of the seminary following Mullins's death in November 1928. He served until 1942, guiding the institution through the difficult years of the Great Depression by employing some creative fundraising, reducing faculty salaries, and renegotiating the existing debt. This 1936 photograph shows Sampey driving a horse-and-buggy in front of Mullins Hall as part of some unidentified event. (Courtesy of SBTS.)

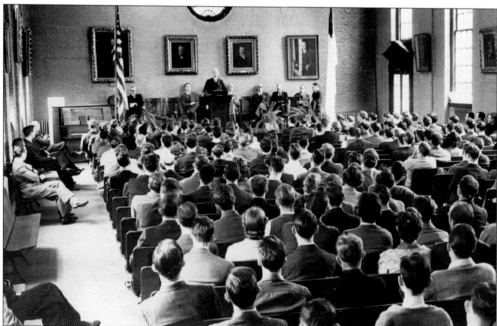

SOUTHERN BAPTIST THEOLOGICAL SEMINARY, SAMPEY PREACHING. John R. Sampey came to the presidency of the seminary from the teaching faculty and, as president, he continued to preach and teach. This late 1930s or early 1940s photograph shows Sampey in front of a gathering of students in the southwest wing of Norton Hall. (Courtesy of SBTS.)

E.A. FULLER PLAYING BASEBALL. Ellis Fuller served as a president of the Southern Baptist Theological Seminary from 1942 until his death in 1950. His tenure was marked by controversy between liberal faculty members and the more conservative administration, which feared that the seminary would acquire a reputation as a liberal school. The problem persisted well after Fuller's death. This 1948 photograph shows Fuller, who had been an amateur baseball player, taking a cut during an informal game. (Courtesy of SBTS.)

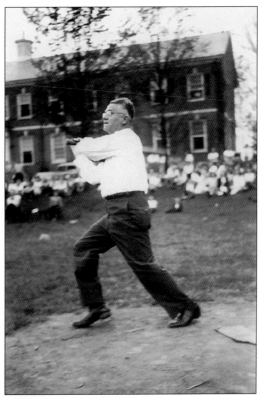

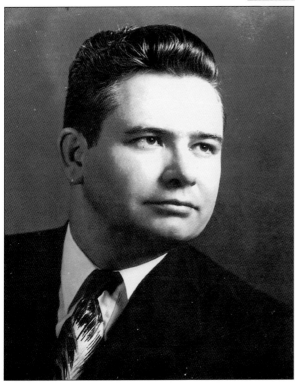

SOUTHERN BAPTIST THEOLOGICAL SEMINARY, DALE MOODY. Dale Moody was a prominent professor of theology who taught at the seminary from 1945 until around 1984 when, as a senior part-time lecturer, he was fired for his liberal theological views. This photograph was made in 1956. (Courtesy of SBTS.)

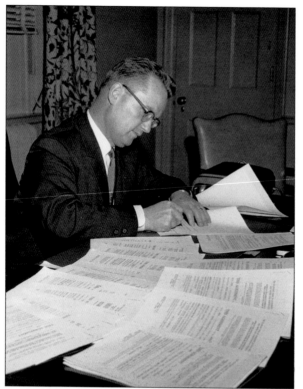

DUKE MCCALL SIGNING CONTRACT FOR LIBRARY. Duke McCall served as president of the Southern Baptist Theological Seminary from 1951 to 1983. He had received his divinity degrees from the seminary and had been well acquainted with his two predecessors, John R. Sampey and Ellis Fuller. Among the accomplishments of McCall's tenure was the building of a new library. This photograph shows McCall signing the construction contract in 1958. (Courtesy of SBTS.)

SOUTHERN BAPTIST THEOLOGICAL SEMINARY, GROUND-BREAKING FOR LIBRARY. Ground was broken for the new library in 1958. The new building was named the James P. Boyce Memorial Library, in honor of the man who first established the seminary in 1859, oversaw its relocation to Louisville in 1873, and remained its president until his death in 1888. (Courtesy of SBTS.)

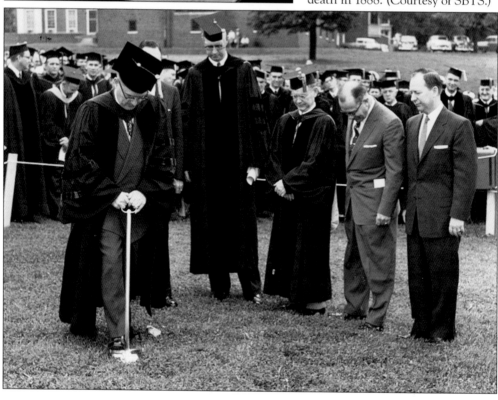

Six

BUSINESSES

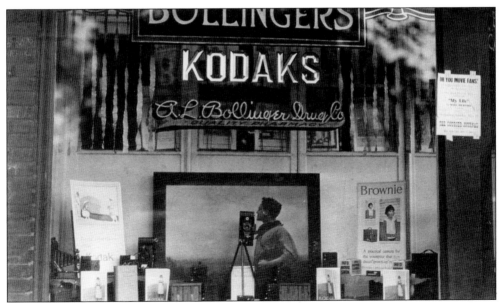

BOLLINGER DRUG STORE. An institution in Crescent Hill, the Bollinger Drug Store replaced what had been Eastern Drug Store around 1913. Albert L. Bollinger, the proprietor, maintained the drugstore in the same location at 2916 Frankfort Avenue for nearly 60 years. After Bollinger's retirement, the building hosted a series of music and consignment stores, most notably Mom's Music, which operated there during the 1980s. (Courtesy of Barbara McGee.)

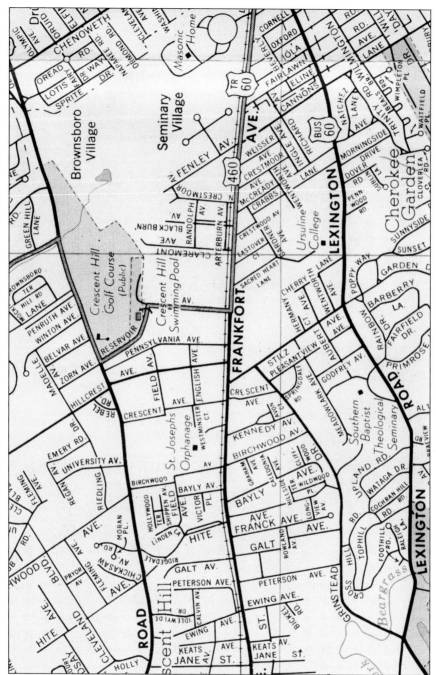

MAP OF CRESCENT HILL, 1950s. This map of Crescent Hill, taken from a standard road map of the 1950s, shows Crescent Hill and its streets when the neighborhood was well developed. The map is oriented so that north is on the left, and the dark road on the left side is Brownsboro Road. Frankfort Avenue and Lexington Road are easily identified, as are the major landmarks of St. Joseph's Children's Home, the Masonic Home, Ursuline College, and the Southern Baptist Seminary. At the bottom of the map, one can read part of the name "Crescent Hill. The mapmaker included a sizeable part of Clifton in the Crescent Hill neighborhood. (Courtesy of the author.)

82

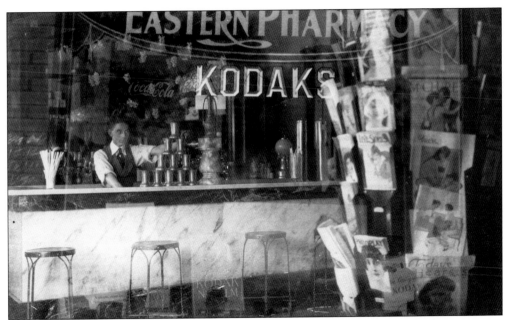

EASTERN PHARMACY. This drugstore, located at 2916 Frankfort Avenue, was the first to occupy the building, which was constructed around 1910. By 1913, it was Bollinger Drug Store. (Courtesy of Barbara McGee.)

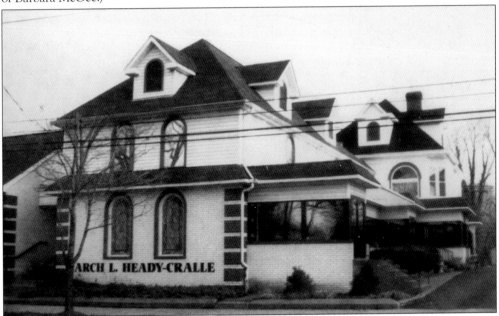

HEADY-CRALLE FUNERAL HOME. This building was the Newton C. Shouse home until the mid-1930s, when Herbert C. Cralle bought it for use as a funeral home. The Cralle family had been funeral directors and embalmers since the early years of the 20th century, and for many years had a funeral home at Sixth and Chestnut Streets in downtown Louisville. The Shouse home was altered and additions were built to make it suitable for the funeral business. Arch Heady, another local funeral director, acquired the home around 1990. It still functions as a funeral home today. (Courtesy of Barbara Sinai.)

ADVERTISEMENT FOR CRESCENT GROCERY. This advertisement from *Beautiful Crescent Hill* (1908) is for one of the first groceries in the neighborhood. It was located at 105 Crescent Avenue, near St. Joseph Children's Home and the former Crescent Hill Post Office. By 1920, other grocery stores along Frankfort Avenue had supplanted this one, and the building was occupied by a hardware store and a plumbing business. Later, from the mid-1930s to the 1950s, the Thrift Food Market would be at this location. (Courtesy of Barbara Sinai.)

ADVERTISEMENT FOR JONES & COMPANY. Frank G. Jones was a coal dealer, and his advertisement in the 1908 book *Beautiful Crescent Hill* was clearly an effort to take advantage of the construction boom in Crescent Hill at that time. His business was located at 2133 Frankfort Avenue in the Clifton neighborhood, and Jones lived for some years at 2820 Field Avenue. Jones began his business some time before 1906 and was out of business by 1920. (Courtesy of Barbara Sinai.)

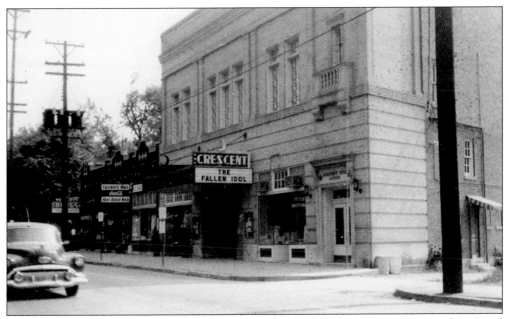

CRESCENT THEATER. The Crescent Theater opened at 2862 Frankfort Avenue around 1927 and was a popular Crescent Hill entertainment venue until it became a "blue" movie theater in the early 1980s and closed in 1987. Dietrich's Restaurant, also known as Brasserie Dietrich, operated there until about 2002, and the building is now an office complex. (Courtesy of CHPC.)

FRANKFORT AVENUE, LOOKING WEST FROM LIBRARY, C. 1950. This view, looking west, shows not only the railroad tracks that have always paralleled Frankfort Avenue but also the stores in the 2700 block of Frankfort, including Hinkebein's Drug Store, the longtime occupant of 2722. (Courtesy of SMEC.)

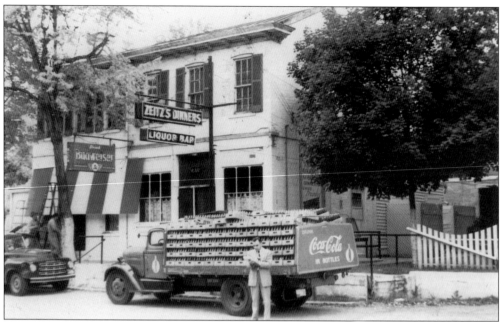

ZEITZ'S DINNERS. This building at 2437 Brownsboro Road, just east of Ewing, dates to the 1860s. For many years it was a grocery, but around 1930, Simon P. Schwartz installed a restaurant there, to which he added a beer garden following the end of prohibition. It became Zeitz's Dinners around 1950, and Min's Steak House about 10 years later. Its current occupant, Pat's Steak House, has been there since the late 1980s. (Courtesy of SMEC.)

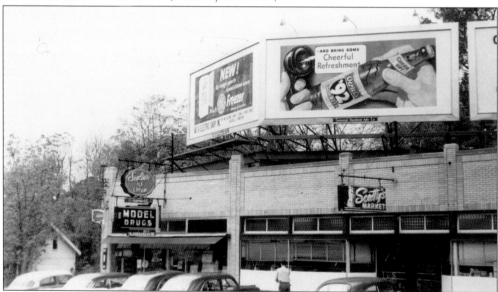

MODEL DRUGS AND SCOTTY'S GROCERY, C. 1950. Located in a yellow brick building at 2915 to 2919 Brownsboro Road, these stores were typical neighborhood shops in 1950, when the photograph was taken. Within a short time, Model Drug Store had been replaced by Krebs' Drugs, which occupied the right two-thirds of the building, where Scotty's had been. In 1970, Modern Way Cleaners and Laundry was there, and a State Farm office moved there in 1997. The left side of the building has been occupied by a liquor store for more than 35 years. (Courtesy of CHUMC.)

2644 Frankfort Avenue. This building was constructed around 1905 in an eclectic revival style. The original owner was W.F. Hartmetz, who ran a hardware store there for many years. For a brief time around 1909, the building also housed the Crescent Hill exchange of the Louisville Home Telephone Company. Hartmetz was something of a character in Crescent Hill. Known as "Uncle Billy," he had a reputation among some as being nasty and mean, but the store had everything a hardware store should have. An art gallery now occupies the building. (Courtesy of KHC.)

2722 Frankfort Avenue. Hinkebein's Drug Store was a longtime occupant of this storefront, which was built around 1920 in a Tudor Revival style, signified by the half-timbered gables at the top of the building. This building was part of a block of 1920s commercial structures that included Shrader's Dry Cleaners at 2724 Frankfort, Steiden's at 2726 Frankfort, and a Piggly Wiggly grocery store at 2730 Frankfort. This stretch of Frankfort Avenue was once lined with elegant residences down to the library. Just Creations, a fair-trade import store, now occupies 2722 Frankfort Avenue. (Courtesy of KHC.)

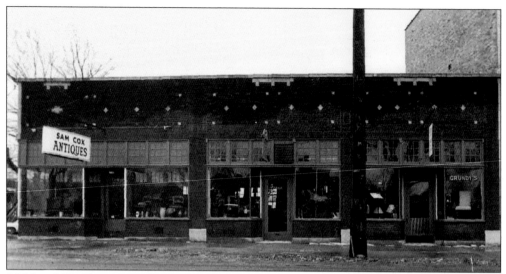

2866 TO 2870 FRANKFORT AVENUE. Built in 1926, this commercial building is made of brick, clad in decorative pressed brick. Multi-paned transoms and a brick parapet with stone, diamond-shaped elements top recessed entries. The first occupants were Vitacream Ice Cream at 2866 Frankfort, Quaker Maid Grocery at 2868 Frankfort, and Frankel-Weisert Drugs at 2870 Frankfort. In 1927, an A&P grocery store moved into 2866 Frankfort and for many years, Grundy's occupied all or part of the building. It was originally a funeral home and then an antique reproduction and interior design shop. Since 2001, the Blue Dog Bakery has been the primary occupant of this building. (Courtesy of KHC.)

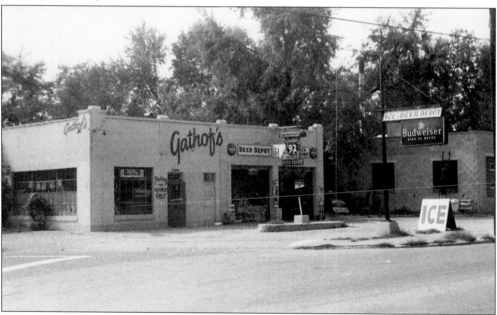

GATHOF'S BEER DEPOT. This site at 3204 Frankfort Avenue was first developed as a gas station in the early 1930s, and operated as such under several different owners. In the mid-1950s, it was transformed into Gathof's Do It Yourself, a hardware store, and soon thereafter, it became Gathof's Beer Depot. By 1960, it was known as the Frankfort Avenue Beer Depot, and it is still operating under that name. (Courtesy of CHPC.)

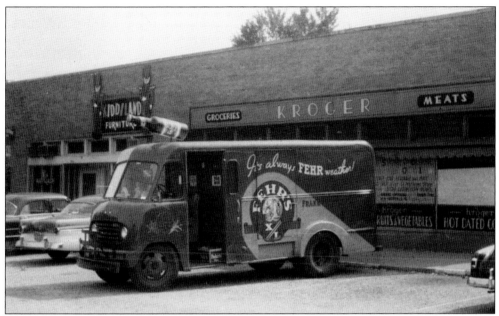

FEHR'S BEER TRUCK AND KROGER STORE. This c. 1955 photograph shows a Fehr's beer truck unloading outside a Kroger grocery store at 3300 Frankfort Avenue. Both Kroger and its next door neighbor, Kiddiland Furniture, moved out shortly after this picture was taken, and the Kroger store became home to the Kirby Company, a vacuum cleaner sales and service store. In the 1970s, the building was razed and replaced with a small strip mall. (Courtesy of CHPC.)

YATES LIQUOR AND BEER. Located at 3220 Frankfort Avenue, near the intersection with Crestmoor, Yates opened just after World War II as a restaurant. George M. Yates was the owner of Yates until the late 1960s, when it became Finnegan's Tavern. Since then, it has operated as a restaurant under several different proprietors. As of 2011, the first floor of the building is vacant, but an apartment in a second-floor addition to the rear of the building is occupied and uses the 3220 Frankfort Avenue address. (Courtesy of CHPC.)

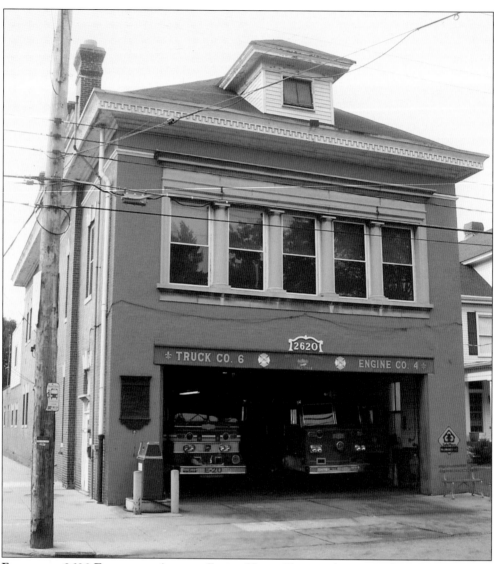

FIREHOUSE, 2620 FRANKFORT AVENUE. Engine House 21, as it is known in the Metro Louisville Fire Department organization chart, was designed by Thomas E. Bohne and built in 1907–1908. It is a utilitarian two-story brick structure without much ornamentation and was built to serve the growing Crescent Hill neighborhood. It still serves the same purpose today. (Courtesy of Steve Wiser.)

Seven

WATERWORKS

CHARLES HERMANY, 1830–
1908. This engraving, published
in *Memorial History of Louisville*,
shows Hermany, a self-taught
engineer. He was appointed chief
engineer for the waterworks in
January 1861 and remained with
the company until his death in
1908. He oversaw the design and
construction of the new reservoir
in 1879 and the pumping station
in 1902, and he spent many
years working on an effective
filtration system. He also drew
up a map in 1887, suggesting
locations in the city for a number
of parks; his ideas were part
of the lead-up to the Olmsted
Brothers design for a park system
that was executed in the 1890s.
Hermany was also very active
in the Church of the Messiah
(First Unitarian Church) for
many years and was a member
of the Salmagundi Club, a social
and literary organization.

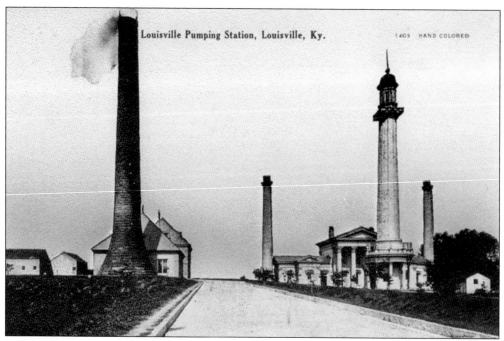

OLD PUMPING STATION. This c. 1909 postcard view shows the old Louisville pumping station with its iconic water tower. Located on the river at the foot of what used to be called Pipe Line Avenue (now Zorn Avenue), it was built between 1857 and 1860. The complex features a 169-foot-tall tower and an adjacent Greek Revival building that held the pumping equipment. Abandoned in the early 20th century when the new pumping station on Frankfort venue began operating, it has been the home of the Louisville Visual Arts Association since 1980. (Courtesy of the author.)

ZACHARIAH SHERLEY, 1801–1879. Sherley, one of Louisville's wealthiest citizens, made his money in river transportation, including a mail line between Louisville and Cincinnati. He sold 100 acres of land to the water company for $60,000 for the new reservoir and later sold the company additional land along Brownsboro Road. He was a trustee of the University of Louisville Medical School, Cave Hill Cemetery, and the Blind Institute. (Courtesy of Lynn Renau.)

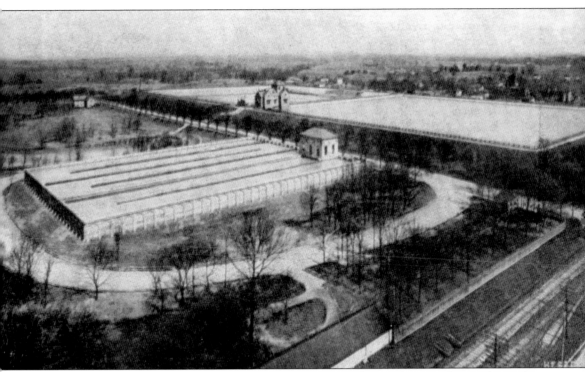

AERIAL VIEW OF COAGULATION BASINS AND RESERVOIR. This c. 1910 aerial view shows the reservoir on the right and the newer coagulation basins, which is part of the filtration process, on the left. The road between them is Reservoir Park Road and runs into Frankfort Avenue. (Courtesy of Judd Devlin.)

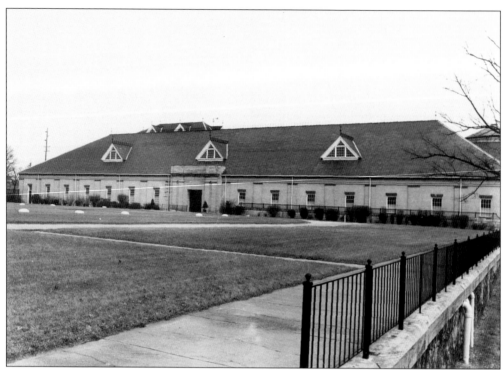

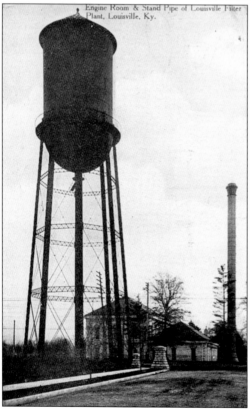

Engine Room & Stand Pipe of Louisville Filter Plant, Louisville, Ky.

NEW FILTRATION PLANT. In the 1880s, the need to filter Louisville's water to remove impurities became evident. Hermany hired George Warren Fuller to devise the best method of filtering water; Fuller submitted his report in 1897, recommending an elaborate sand-and-gravel system. Building the plant took 10 years, and the first tests were run in 1908, on the very day that Hermany died. The plant opened in July 1909 and is considered an excellent example of early industrial architecture. (Courtesy of KHC.)

FILTRATION PLANT WATER TOWER. The water tower, a distinctive part of the Crescent Hill landscape ever since its construction in 1905, had a capacity of 1.2 million gallons. By the 1960s, its usefulness was limited to the filtration plant complex. Surprisingly, it survived the 1974 tornado, but age-related deterioration forced the water company to dismantle it in 1985. (Courtesy of the author.)

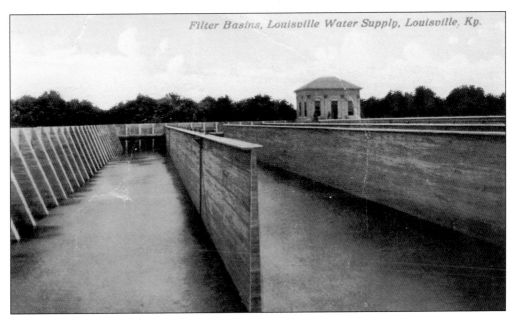

Filter Basins, Louisville Water Supply, Louisville, Ky.

CLOSER VIEW OF COAGULATION BASINS. This unusual postcard view presents a close-up view of the coagulation basins at the Louisville Water Company's filtration plant. (Courtesy of the author.)

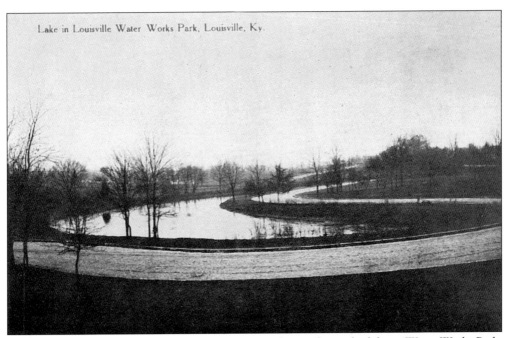

Lake in Louisville Water Works Park, Louisville, Ky.

LAKE AT WATER WORKS PARK. This c. 1910 postcard view shows the lake at Water Works Park. It was actually a low spot across from the reservoir that was a catch basin for the reservoir. It is likely that people swam in it, but the concrete pool that opened nearby in 1934 was a better option for swimmers (see page 116). (Courtesy of the author.)

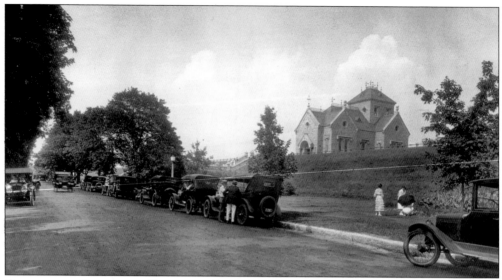

ENJOYING THE PARK AT THE RESERVOIR. From the beginning of the construction of the reservoir and later the filtration plant, Charles Hermany and others wanted the surrounding land to be a park-like area open to the public. A swimming pool was there for many years, as well as picnic grounds and a public golf course. This 1921 photograph shows many automobiles parked along Reservoir Road while their occupants enjoyed the day. (Courtesy of Keith Clements, photograph by Caufield and Shook.)

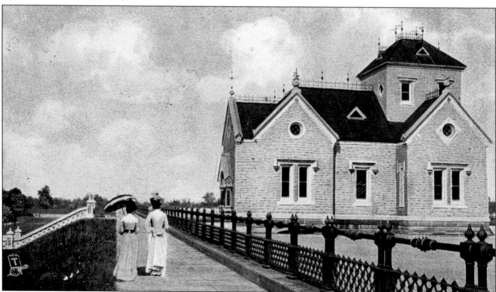

RESERVOIR GATEHOUSE AND WALKWAY. This three-story building houses the valves that control the water level in the reservoir. Charles Hermany designed the Gothic Revival building, which resembles one he saw along the Rhine River in Germany. Hermany, with an eye for appropriate detail, included a variety of water-related ornamental sculptures and symbols. When the reservoir was built in 1879, it included a walkway around its perimeter. It soon became a popular place to stroll, as this c. 1910 postcard view shows, and it is still used for walking and jogging today. Much of the fencing around the reservoir and along the stairs leading up to the gatehouse was destroyed in the 1974 tornado. (Courtesy of the author.)

Eight
PEOPLE AND ACTIVITIES

HARDA MORRIS ON FRANKFORT AVENUE. Harda Morris, who grew up on Pennsylvania Avenue in the 1930s and attended George Rogers Clark Elementary School and Barret Junior High School, is shown here posing in front of the Crescent Hill Baptist Church on Frankfort Avenue in the late 1930s. (Courtesy of Mary Bateman.)

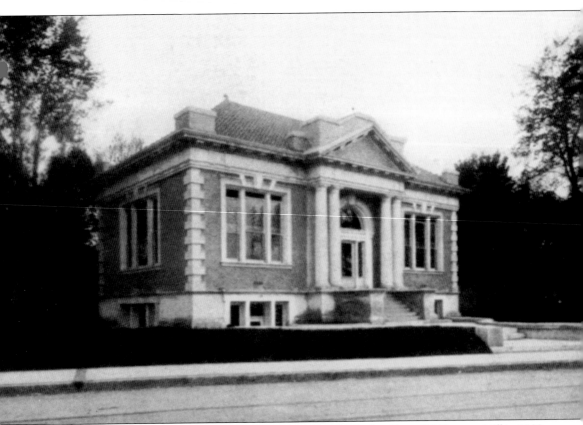

CRESCENT HILL LIBRARY. This photograph, originally published in *Beautiful Crescent Hill* in 1908, shows one of the most familiar buildings in Crescent Hill. The branch library was designed by the architectural firm of Thomas and Bohne and was built in 1908 at a cost of just over $26,000. Located at 2762 Frankfort Avenue, the library served as a meeting place for many community groups, including the Crescent Hill Women's Club, until they found their own homes. Much of this was due to the work of Sallie L. Berryman, who was the librarian from 1909 to 1939. (Courtesy of Barbara Sinai.)

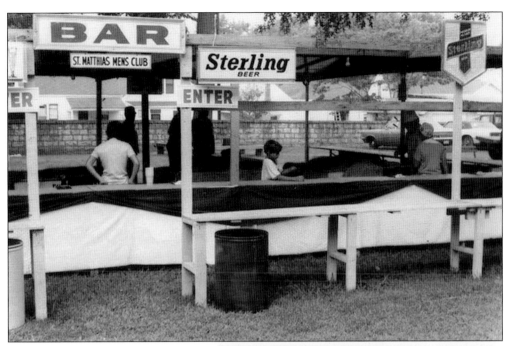

St. Joseph Children's Home Picnic, 1972. One of Crescent Hill's most well-known and popular social events of the year is the picnic fundraiser that St. Joseph's Home hosts every August. This photograph shows one of the beer stands and some workers getting ready for the several thousand people who will attend. (Courtesy of SJCH.)

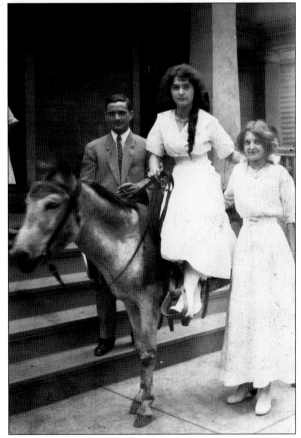

Posing with the Photograph Pony. This mid-1920s photograph shows Eastover resident Martha Moore sitting on a pony that was probably brought there by an entrepreneur trying to make money by having children's pictures made. (Courtesy of Judd Devlin,)

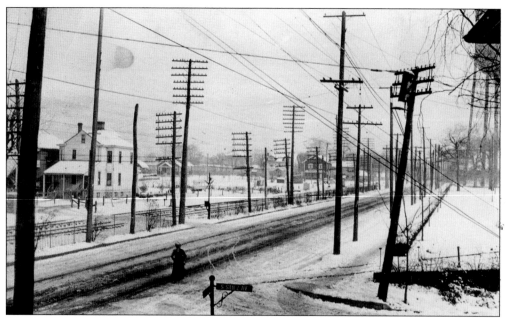

STILZ AVENUE IN WINTER. Snow does not come too often to Louisville, but it is an adventure when it does. This c. 1920 photograph shows the intersection of Frankfort and Stilz Avenues, looking east down Frankfort. One can see the railroad tracks that run along Frankfort, and the houses in the background appear to be located on Forest Court. (Courtesy of Barbara McGee.)

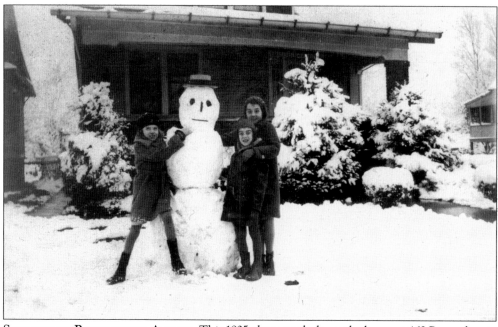

SNOWMAN ON PENNSYLVANIA AVENUE. This 1935 photograph shows the house at 162 Pennsylvania Avenue. The snowman builders are Harda Morris, Leroy Martin, and Peary Sparkman. (Courtesy of Mary Bateman.)

EASTOVER PARK KIDS. This 1920s photograph shows a group of Eastover Park kids happily posing. In front is Virginia Wynn, and in back, from left to right, are T.J. Knight, Jim Craik, Nell Craik, Mary Moore, and Martha Moore. (Courtesy of Judd Devlin.)

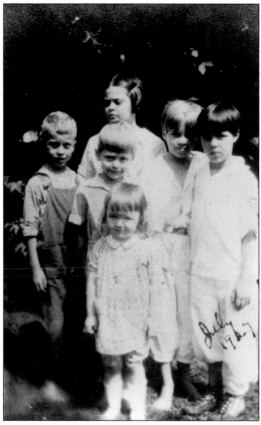

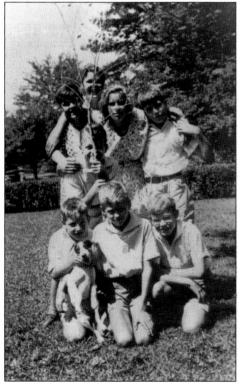

MORE EASTOVER PARK KIDS. Eastover Park was a close-knit community where many children played together and eagerly posed for pictures. This 1920s photograph, taken in front of 23 Eastover, shows (first row) Dave Bruning, Jim Craik, and Addison Lee; (second row) Martha, Evelyn, and Mary Moore. Bud Bruning in the back and Jim Chase is in the middle. (Courtesy of Judd Devlin.)

HELEN BOGGESS ON PETERSON AVENUE. Helen Boggess was a friend and classmate of Harda Morris. In this photograph, she is posing in front of the Russell House at 205 South Peterson (see page 20). (Courtesy of Mary Bateman.)

BARRET SCHOOL CHAMPIONSHIP SOCCER TEAM. This photograph shows the girls' champion soccer team from Barret Junior High School in December 1938. Team members were in the seventh and eighth grades. (Courtesy of Mary Bateman.)

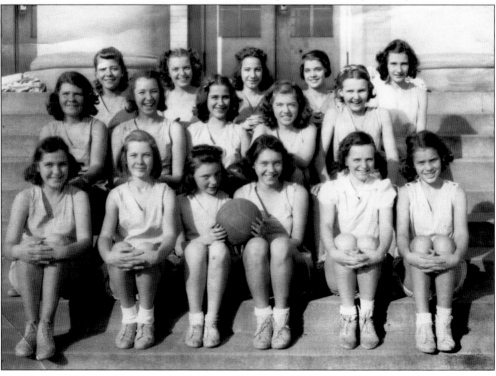

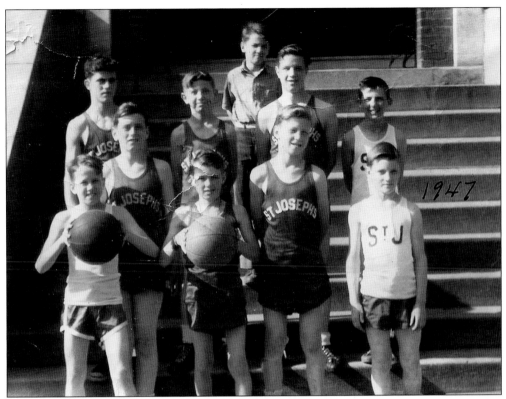

St. Joe's Basketball Team, 1947. Both the Masonic Home and St. Joe's had various sport teams that probably played in local leagues and occasional tournaments. This photograph shows the 1947 basketball team from St. Joseph Children's Home. (Courtesy of SJCH.)

Crescent Hill Baptist Church Basketball Team, c. 1955. In the 1950s, city league sports seemed to be important to the Crescent Hill Baptist Church, which had an easy requirement for one to join a team. The church asked only that players attend services or Sunday school twice a month. This image shows a basketball team from around 1955, with Coach Monty Justice in the center. (Courtesy of John Arnett.)

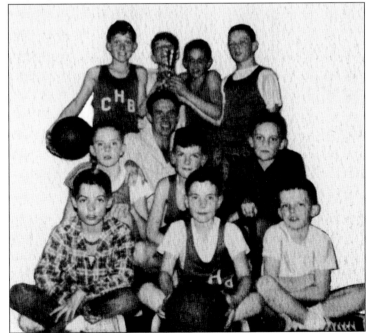

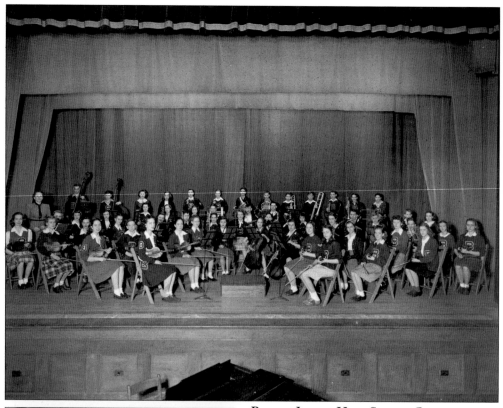

BARRET JUNIOR HIGH SCHOOL ORCHESTRA, 1949. This photograph, taken from the balcony of the Barret Junior High School auditorium, shows the school's orchestra and suggests the importance that was placed on music in the schools 60 years ago. (Courtesy of JCPS.)

HARDA MORRIS PLAYS A FAIRY. Harda Morris was a sixth-grade student at Clark Elementary School when she played a fairy in the acclaimed "The Cobbler of Fairyland," which was presented in the auditorium of Barret Junior High School in the mid-1930s. (Courtesy of Mary Bateman.)

Oscar Rehm, Troop 1. Troop 1, sponsored by the Crescent Hill United Methodist Church, was the first Boy Scout troop established in Louisville and one of the first in the United States. Oscar Rehm was an original member of Troop 1. This troop celebrated its centennial in 2010 and is currently the only active Boy Scout troop in Crescent Hill. (Courtesy of Linda Gray.)

Boy Scout Troop 1, Pilgrimage, 1913. This photograph shows a group of Scouts from Troop 1 on a pilgrimage in 1913. Unfortunately, the object and destination of their pilgrimage is unknown. (Courtesy of Linda Gray.)

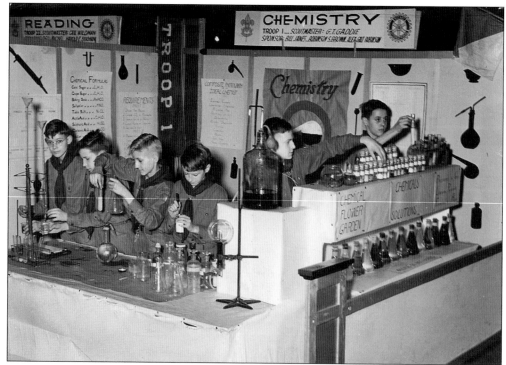

BOY SCOUTS AND CHEMISTRY EXHIBIT, 1938. Boy Scouts could earn a merit badge in chemistry, and this photograph shows a group of Scouts from Troop 1 doing chemistry demonstrations at some sort of Boy Scout fair in 1938. (Courtesy of Linda Gray.)

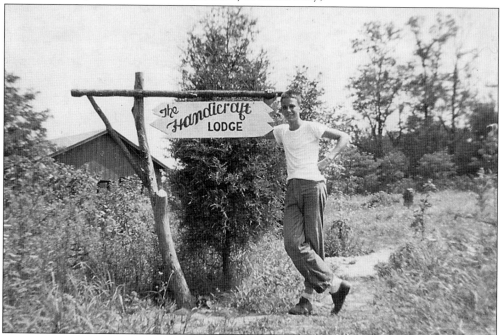

MERLE MILLER AT SUMMER CAMP. Merle Miller, a member of Troop 1, is shown here headed toward the Handicraft Lodge at summer camp, some time in the 1950s. (Courtesy of Linda Gray.)

MERLE MILLER RECEIVING HIS EAGLE AWARD. Quite obviously, Miller did well at camp and elsewhere in his scouting endeavors, since this photograph shows his proud mother pinning on his Eagle badge after he had earned scouting's highest award. (Courtesy of Linda Gray.)

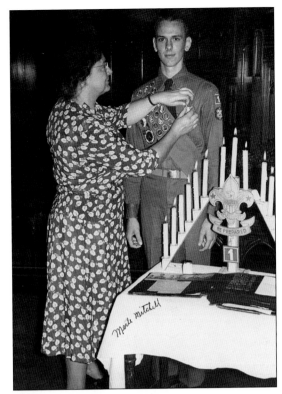

LUMINARIA, 1964. When Troop 1 had its annual award celebration, Scouts put paper lanterns along the sidewalk leading to the Methodist church. They called the lighting ceremony Luminaria, and it obviously added a special touch to the occasion. (Courtesy of Linda Gray.)

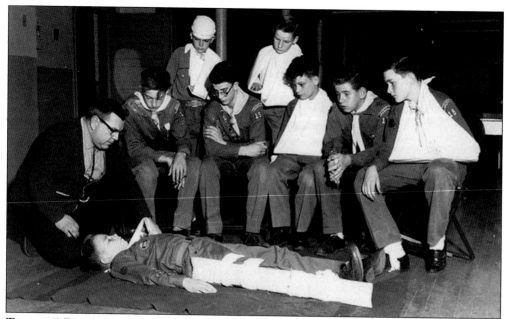

TROOP 15 BOY SCOUTS LEARN FIRST AID. In the 1950s, there were six Boy Scout troops in Crescent Hill, all sponsored by the mainstream churches, St. Joseph's, and the Masonic Home. Here, Scouts of Troop 15, the St. Joseph's troop, get a lesson in first aid. (Courtesy of SJCH.)

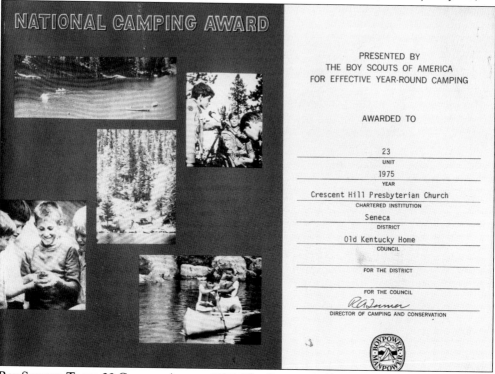

BOY SCOUTS, TROOP 23 CAMPING AWARD, 1975. The Crescent Hill Presbyterian Church sponsored Troop 23, chartered in 1916, for about 60 years until it disbanded in the mid-1970s. This image is a certificate for excellence in camping that the troop earned in 1975. (Courtesy of the author.)

CRESCENT HILL GOLF COURSE, SEVENTH HOLE. The Crescent Hill Golf Course, extending along the south side of Brownsboro Road east from Reservoir Park Drive, was built in 1926 on land once owned by the water company. The architect was George Davis, who laid out a sporty, 3,200-yard, 9-hole course at a cost of about $10,000, half paid for through subscriptions by local residents and half by the Louisville Parks Board. Although this is a contemporary photograph, the layout of the course is almost identical to what it was when it first opened. (Courtesy of the author.)

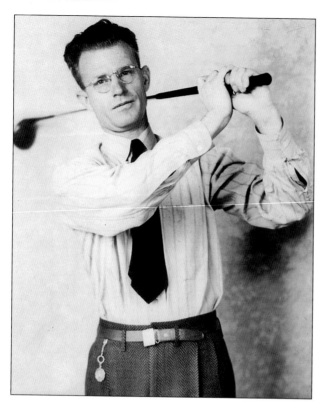

RAY OTTMAN. The first professional at the Crescent Hill Golf Course, Ray Ottman had a distinguished career in Kentucky golf. He served as Crescent Hill's professional from 1926 to 1932 and then went to Big Springs Country Club, where he stayed until 1946. In 1947, he opened a driving range in the St. Matthews area. He won the Kentucky Open three times and was inducted into the Kentucky Golf Hall of Fame in 2008. (Courtesy of Diane Bonifield.)

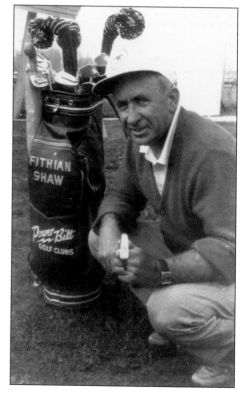

FITHIAN SHAW. Fithian Shaw was the popular professional at Crescent Hill from 1949 to 1958. He won the Kentucky PGA tournament in 1955 and was runner-up twice in the Kentucky Open. Born in 1914, he served in World War II and worked at Cherokee Golf Course after his discharge. In 1958, he became head professional at the Owensboro Country Club for seven years. In the mid-1960s, he returned to Louisville and eventually opened his own golf shop and driving range on Shelbyville Road. (Courtesy of Diane Bonifield.)

SHAW AND A JUNIOR GOLFER. In the years after World War II, golf became more of a middle-class activity. Both private country clubs and municipal courses sponsored programs for junior golfers. In this 1950s photograph, Fithian Shaw consults with an unidentified junior golfer at the Crescent Hill Golf Course. (Courtesy of Diane Bonifield.)

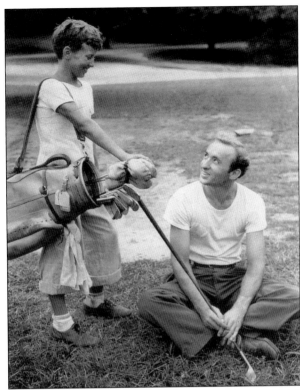

1957 JUNIOR FALLS CITIES TOURNAMENT. Crescent Hill Golf Course hosted the 1957 Junior Fall Cities tournament for young golfers from the Louisville area. In this photograph of the awards ceremony, Fithian Shaw is at the far left. Next to him is Bruce Wyatt, the runner-up; Frank Beard, the champion; and Bill Moore, the parks director. Beard went on to have a long and distinguished career as a professional golfer. (Courtesy of Diane Bonifield.)

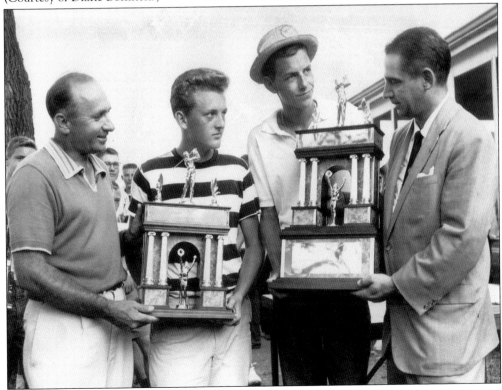

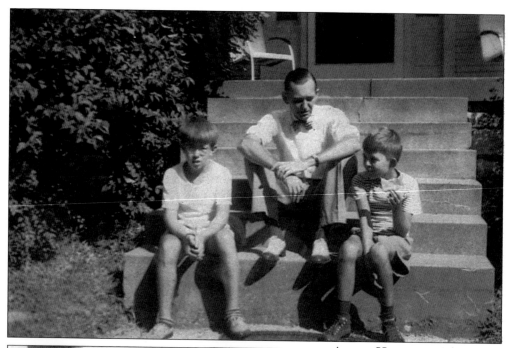

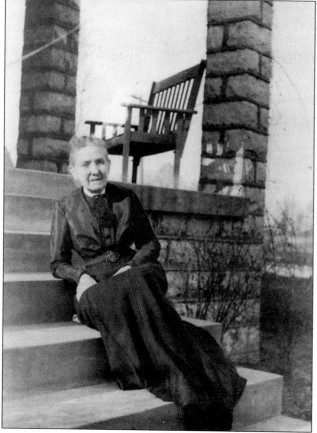

AT THE HAMPTONS. This 1939 photograph shows (from left to right) John Gray Perry, Gray Hampton, and Carter Gray Hampton sitting on the steps of the Hampton family home on Brownsboro Road. The house, built in 1910, was the family home of John and Annie Gray Hampton. (Courtesy of Ed Perry.)

"AUNTIE" GRAY. Auntie Gray, probably Annie Gray Hampton's sister, is shown here relaxing on the steps of the family home on Brownsboro Road in the 1920s. She was the grandmother of current Crescent Hill resident Ed Perry. (Courtesy of Ed Perry.)

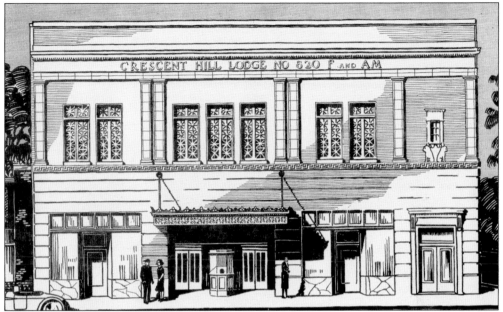

MASONIC BUILDING, 2858 FRANKFORT AVENUE. The original home of Crescent Hill Lodge No. 820, this building dates to 1927 and was designed by Alfred Weindel in a Classical Revival style. After service as a lodge hall, the building was the Crescent Theater for a number of years, Dietrich's Restaurant, the Young Realty Company, and Woodside, the Cleaner. (Courtesy of Doris Lamb.)

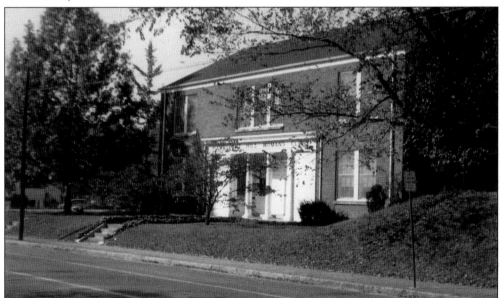

CRESCENT HILL WOMEN'S CLUB. The Crescent Hill Women's Club was the result of a merger between the Crescent Hill Civic League and the Crescent Hill Mother's Club, some time around 1920. It was under the guidance of Sallie T. Berryman, the first librarian of the Crescent Hill library. The women's club met at the library from 1920 until the mid-1930s. After meeting at the Masonic Hall for a couple of years, the members moved into their new Georgian Revival clubhouse at 2641 Grinstead Drive in 1937 and are still meeting there today. (Courtesy of CHPC.)

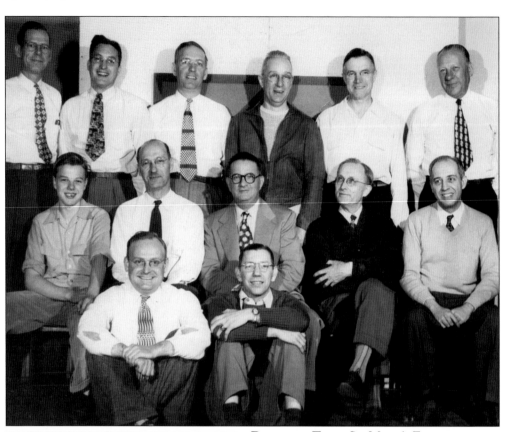

Dart ball Team, St. Mark's Episcopal Church. This c. 1943 photograph shows the members of the St. Mark's Episcopal Church dart ball team. Dart ball is a game in which competitors throw darts into a board with markings like a baseball diamond and scoring roughly parallels the rules of baseball. (Courtesy of Barbara McGee.)

FINAL ALL STAR GAMES

Between

The Highland and Crescent Hill Church Dart Ball Leagues

•

Tuesday, December 14, 1948, 8:00 P.M.

Christ Evangelical and Reformed Church Auditorium
Barret and Breckinridge

Tournament Program, Local Dart ball League. In the 1940s, dart ball competitions were very popular among churches and other social organizations. Leagues were formed and tournaments were held periodically. This is a program from a local tournament in which the St. Mark's team competed. It is unknown whether St. Mark's was a winner. (Courtesy of Barbara McGee.)

RESERVOIR PARK PLAYGROUND. On the grounds of the water company near the reservoir, a place often called Reservoir Park (and therefore confused with the subdivision of the same name), were a number of recreational facilities, including this playground, seen here in a rare photograph devoid of children. (Courtesy of CHPC.)

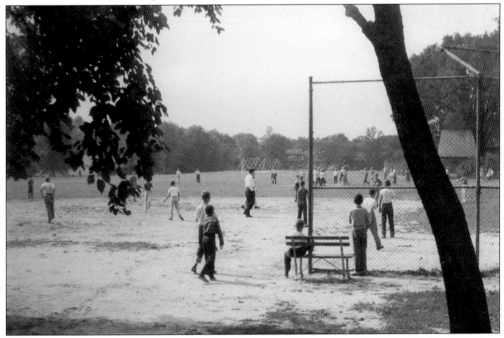

EMMET FIELD SCHOOL PLAYGROUND. School playgrounds were popular places for local children to play at almost any time when school was not in session. Here, a large number of children are enjoying the amenities of the Emmet Field school playground, located not far from the reservoir. (Courtesy of CHPC.)

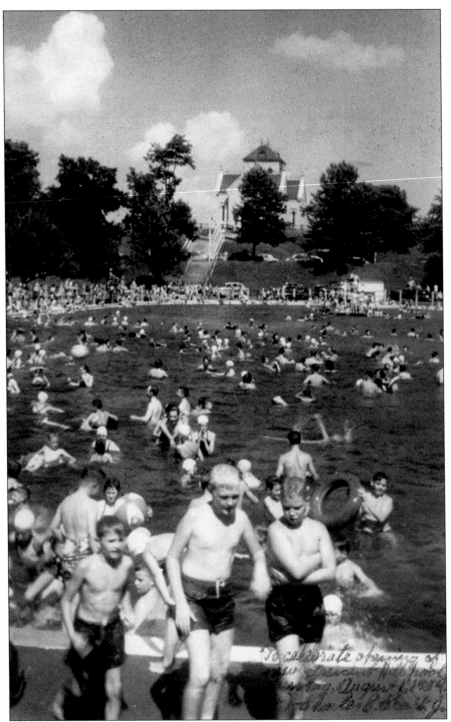

CRESCENT HILL SWIMMING POOL. This 1934 photograph shows the public swimming pool built on the water company's property near the reservoir. It was a popular summer attraction for many years. An indoor pool and fitness center, called the Mary T. Meagher Center, has replaced the outdoor facility. (Courtesy of Barbara McGee.)

Nine

CRESCENT HILL AND THE 1974 TORNADO

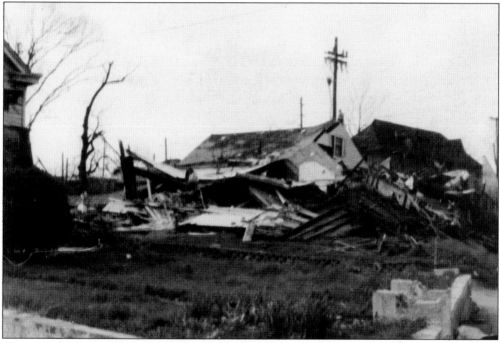

TORNADO DAMAGE, CRESCENT HILL. Late in the afternoon of April 3, 1974, a series of tornadoes swept through the lower Midwest, including Louisville. Louisville's tornado caused considerable damage at the Kentucky Fair and Exposition Center, destroyed hundreds of mature trees in Cherokee Park, and then moved northeast into Crescent Hill. It crossed Lexington Road and passed through the Southern Baptist Theological Seminary, taking out many trees, but doing relatively little damage to the buildings. It destroyed an entire block of houses on Grinstead Drive, moved through part of the water company property, and then hit Forest Court and the south end of Hillcrest Avenue particularly hard. After uprooting some trees on the golf course, it continued to the northeast, wreaking great havoc in neighborhoods near the Watterson Expressway. (Courtesy of Mary Bateman.)

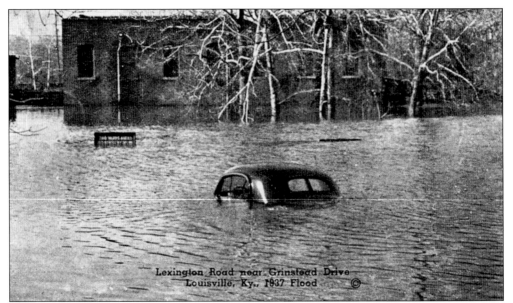

Lexington Road near Grinstead Drive
Louisville, Ky., 1937 Flood ©

1937 FLOOD IN CRESCENT HILL. The 1974 tornado was not the only natural disaster in Louisville's history. Louisville's worst flood came in 1937, but the elevated nature of Crescent Hill spared its residents from rising water. However, the southwestern corner of Crescent Hill at the corner of Grinstead and Lexington Roads was low enough to attract floodwaters, as this contemporary postcard view shows. (Courtesy of the author.)

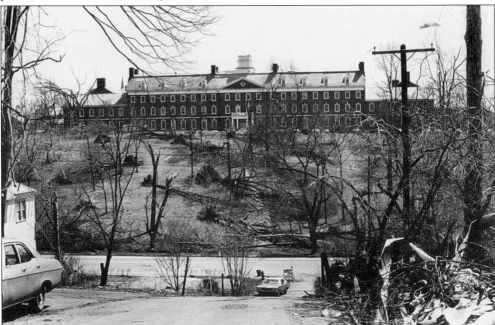

TORNADO DAMAGE, SOUTHERN BAPTIST THEOLOGICAL SEMINARY. The tornado crossed Lexington Road west of the seminary and hit Grinstead Drive just east of Barret Junior High School. This photograph of the seminary, taken from South Birchwood Avenue on the other side of Grinstead, shows the large seminary building that has lost its cupola and many of the uprooted trees on the campus. (Courtesy of SBTS.)

118

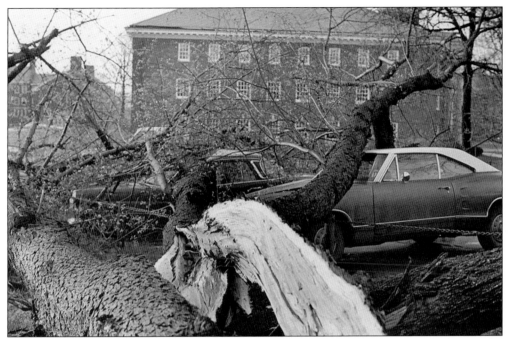

TORNADO DAMAGE, SOUTHERN BAPTIST THEOLOGICAL SEMINARY. Much of the damage at the seminary was related to the inability of trees to withstand the powerful winds. Here, fallen trees have made a mess of a campus parking lot. (Courtesy of SBTS.)

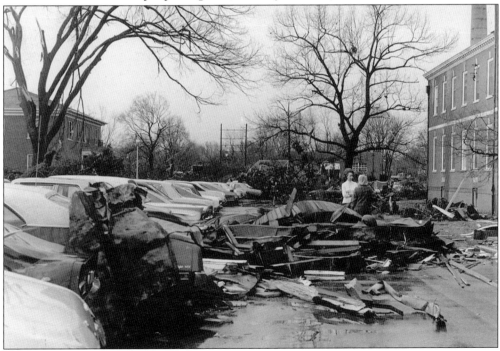

TORNADO DAMAGE, SOUTHERN BAPTIST THEOLOGICAL SEMINARY. In another parking lot at the seminary, two students discuss the current state of affairs, ignoring the large rock (in the left foreground) that rests on the trunk of a car. (Courtesy of SBTS.)

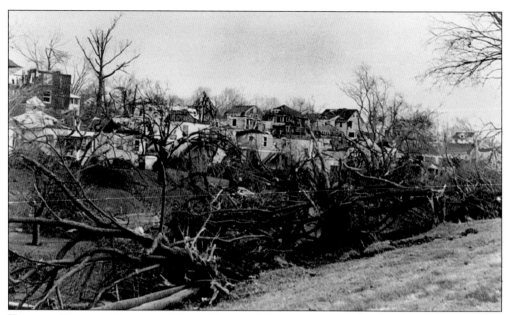

TORNADO DAMAGE, GRINSTEAD DRIVE. Grinstead Drive was among the Crescent Hill streets that suffered the worst tornado damage. This photograph, taken from the seminary grounds, shows the 2700 block of Grinstead in shambles, with damaged houses on South Birchwood Avenue in the background. (Courtesy of SBTS.)

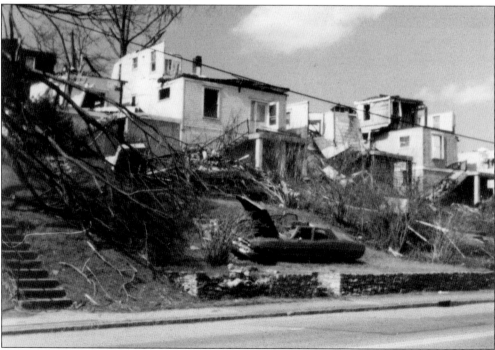

TORNADO DAMAGE, GRINSTEAD DRIVE. This photograph provides a closer look at two badly damaged houses in the 2700 block of Grinstead Drive. The tornado damaged 480 houses in Crescent Hill, and around 80 were beyond repair; the two pictured were among the 80. (Courtesy of Mary Bateman.)

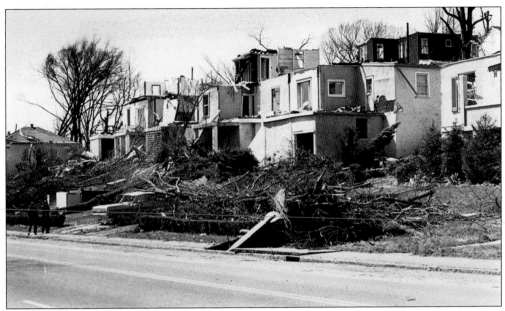

TORNADO DAMAGE, GRINSTEAD DRIVE. Here is another view of the extreme tornado damage on Grinstead Drive. Virtually every house in the 2700 block was demolished. The block now features a line of apartment buildings. (Courtesy of SBTS.)

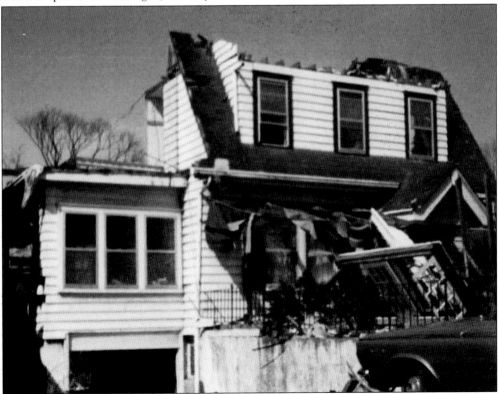

TORNADO DAMAGE, GRINSTEAD DRIVE. This house on Grinstead Drive was one of those that, in all likelihood, did not survive the tornado. (Courtesy of SBTS.)

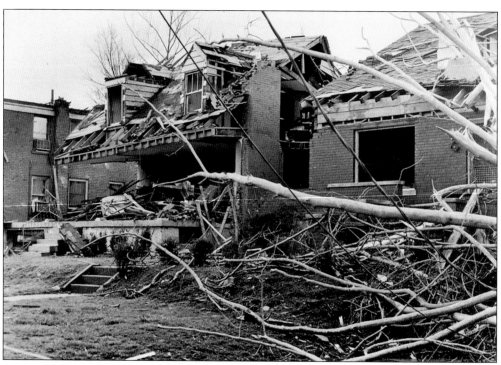

TORNADO DAMAGE, GRINSTEAD DRIVE. Even brick houses did not fare well against the force of the tornado winds. (Courtesy of SBTS.)

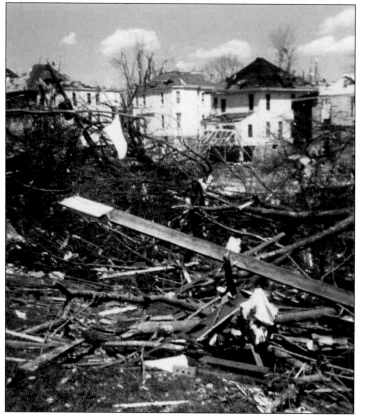

VIEW ALONG CRESCENT COURT. Crescent Court is a short street that runs between Frankfort Avenue and Grinstead Drive. Along with Kennedy Court, which is one block west, it was home to some of Crescent Hill's earliest and most prominent families, but the tornado destroyed several homes on the south end of the court near Grinstead Drive. (Courtesy of Steve Wiser.)

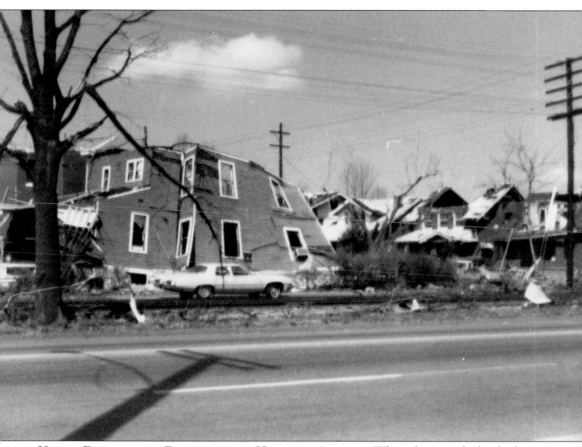

HOUSES DESTROYED AT FRANKFORT AND HILLCREST AVENUES. When the tornado finished its work on Grinstead Drive, it moved northeast through a corner of water company property and concentrated its force on the intersection of Frankfort and Hillcrest Avenues. This photograph shows the destroyed house at 102 Hillcrest Avenue, next to the railroad tracks. A three-unit apartment building stands there now. (Courtesy of Mary Bateman.)

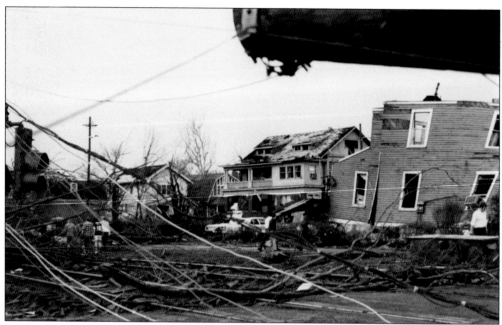

DAMAGE ON FOREST COURT. Forest Court is a small, one-block street tucked in behind Hillcrest, but it suffered extensive tornado damage. This photograph shows the house at 105 Forest Court, just behind 102 Hillcrest Avenue, with major damage. The house survived and remains a private residence today. (Courtesy of Barbara McGee.)

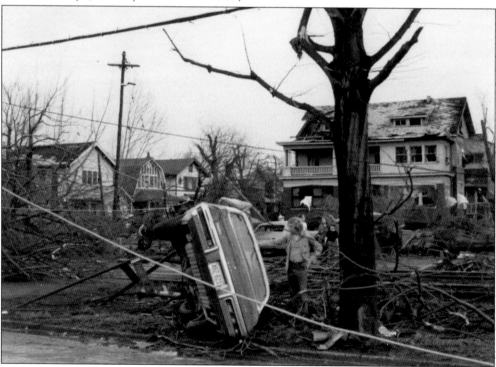

DAMAGE ON FOREST COURT. This is another view of Forest Court that shows the house at 105 behind the tree and a woman looking at a displaced automobile. (Courtesy of Barbara McGee.)

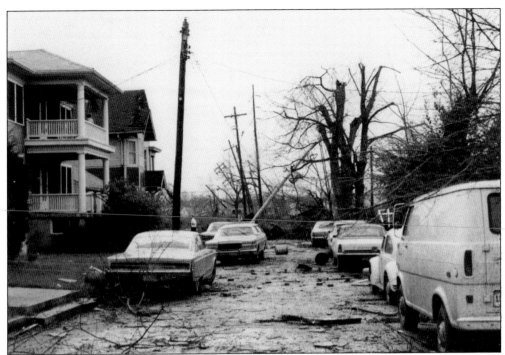

DAMAGE ON FOREST COURT. This view looks south down Forest Court. The houses at 107 and 109 are seen at the left of the photograph, with a broken utility pole at the end of the street. The house at 105, seen in the previous pictures, is just around the corner to the left. (Courtesy of Barbara McGee.)

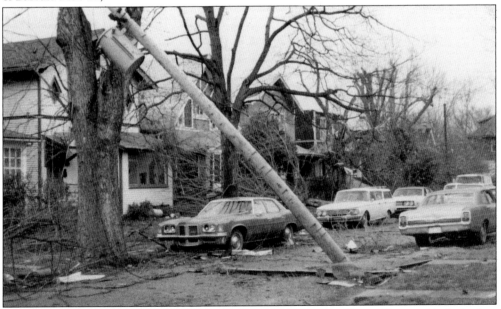

DAMAGE ON FOREST COURT. This photograph shows the west side of Forest Court, with the broken utility pole seen in the previous photograph. The houses at 108, 110, 112, and 114 seem to have weathered the tornado fairly well. All of the houses on Forest Court were repaired and remain private residences today. (Courtesy of Barbara McGee.)

WHEN THE TORNADO STRUCK THE SEMINARY. The tornado hit the Southern Baptist Theological Seminary and knocked out its electric power at 4:43 p.m. Someone thought to record that fact with this stark photograph. (Courtesy of SBTS.)

BEGINNING THE RELIEF EFFORTS. Within a very short time, tornado victim relief efforts began to be organized. At the Southern Baptist Theological Seminary, this room was designated for the receipt of blankets and other relief supplies. (Courtesy of SBTS.)

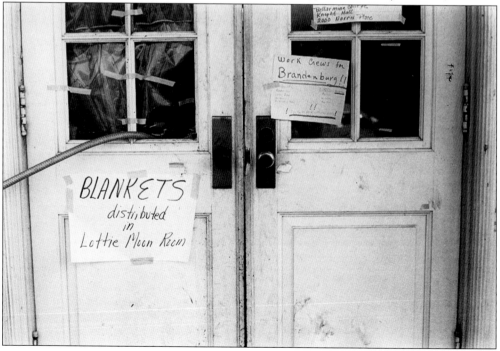

FURTHER READING

Anderson, James C. and Donna M. Neary. Images of America: *Louisville*. Charleston, SC: Arcadia Publishing, 2001.

Dietz, Robert E., ed. *Tornado!* Louisville: Pinaire Lithographing, 1974.

Falls of the Ohio Metropolitan Council of Governments. *Preservation: Metropolitan Preservation Plan*. Washington, DC: US Department of Housing and Urban Development, 1973.

Findling, John E. Postcard History: *Louisville*. Charleston, SC: Arcadia Publishing, 2009.

Kleber, John E., ed. *Encyclopedia of Louisville*. Lexington: University Press of Kentucky, 2001.

Rutherford, Glenn O. *Love's Home: The Works and Wonders of St. Joseph Children's Home, 1849–2002*. Louisville: AGI Media, 2002.

Smith, Kelley Dearing. *Water Works: 150 Years of Louisville Water Company*. Louisville: Butler Books, 2010.

Thomas, Samuel W. and Deborah M. Thomas. *Crescent Hill: Its History and Resurgence*. Louisville: Butler Books, 2011.

Thomas, Samuel W. *Crescent Hill Revisited*. Louisville: George Rogers Clark Press, 1987.

Ursuline Campus Schools. *Sacred Heart Academy: 125 Years of Excellence in Education Rooted In Ursuline Tradition*. Louisville: Ursuline Campus Schools, 2002.

Wills, Gregory A. *Southern Baptist Theological Seminary, 1859–2009*. New York: Oxford University Press, 2009.

Yater, George. *Two Hundred Years at the Falls of the Ohio: A History of Louisville and Jefferson County*. Louisville: The Filson Club, 1987.

DISCOVER THOUSANDS OF LOCAL HISTORY BOOKS FEATURING MILLIONS OF VINTAGE IMAGES

Arcadia Publishing, the leading local history publisher in the United States, is committed to making history accessible and meaningful through publishing books that celebrate and preserve the heritage of America's people and places.

Find more books like this at
www.arcadiapublishing.com

Search for your hometown history, your old stomping grounds, and even your favorite sports team.